Starting to paint with acrylics

Starting to
paint with acrylics

John Raynes

Studio Vista, London
Taplinger/Pentalic, New York

First published in the United States in 1980 by
TAPLINGER PUBLISHING CO., INC.
New York, New York

Printed in Holland

Library of Congress Catalog Card Number: 79-56682
ISBN 0-8008-7385-8

Contents

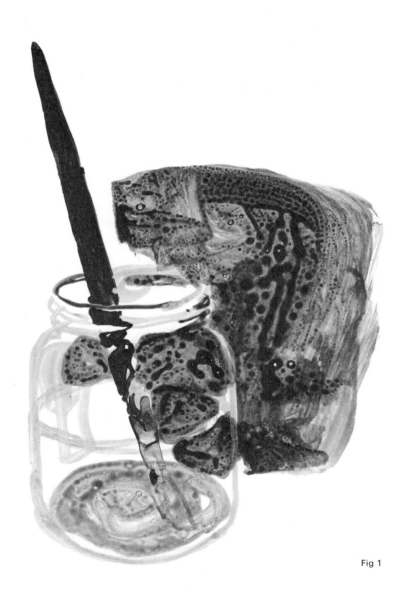

Fig 1

Introduction

Since prehistoric times, man has been using paint or pigments to make images and designs on more or less flat surfaces. The acrylic (plastic) paints and techniques to be discussed in this book are the most recent additions to what has been a continuous development of the materials available to the artist.

I shall attempt to provide as many facts about acrylic paints as are of practical use, together with some opinions and advice based on practical experience in the use of the new materials. I shall advise on the handling of materials and the order of procedure in the studio and outside, so as to minimize the effect of inadequate technique. The nature of light, and thence colour theory, some understanding of which I think is of first importance, will be discussed at some length. There will be some analysis of composition and design, but with the minimum of actual direction about exactly how or what one should paint.

Painting, for the amateur especially, should be personal and, if possible, uninfluenced. The untrained painter's main asset is his comparative freedom from the strictures of professional teaching and opinion. The so-called 'Sunday painters', and folk paintings of all ages and cultures, have shown us that lack of training need be no disadvantage. The freshness of vision and uncluttered simplicity of all good painting is available to everyone. The difficulty lies in filing what one has been taught in some recess of the brain, so that it does not interfere with what one can learn from observation and intuition.

The use of acrylic resins gives yet more freedom. There are fewer laws to be observed, and more possibilities than ever before. This book, therefore, is intended to be about possibilities, not limitations, and about how to make the most of these possibilities by understanding the medium and making it work for you.

1 Equipment and materials

Pigments

'Pigment or powdered colour mixed with a medium so that it can be applied to and will adhere to a surface' is a rough definition of paint.

Coloured clays, natural or burnt, crushed insects and plant juices mixed with water, animal fats or wax, were used in the earliest paintings. The ancient Egyptians probably used a gum or size to hold pigments together, and painted with them on mud or plaster walls, and early Greek pictures are supposed to have been painted with oil, egg tempera or emulsified wax, although there is still some doubt about their exact chemical make-up. Certainly egg yolk as a medium for mixing pigments was used in Byzantine and early Christian art, and was the principal medium in Europe until oil paint began to replace it around the sixteenth century. Oil painting started much earlier than the sixteenth century, and tempera painting did not completely disappear at this time, but the techniques of oil painting became so developed and refined, especially in Italy, that by the seventeenth century it was in almost universal use. Since that time developments have been mainly in the direction of refinement of colours and diversification of types and grades of paints available to everyone.

Really pure, bright colours, especially purples and reds, were difficult or impossible to obtain from any known source, and were not as impervious to light as was needed for some uses. The automobile manufacturers were the first to experiment with acrylic paints, which they found combined brightness with resistance to fading and darkening and other atmospheric attacks. The possibilities of the new medium are now fully appreciated by all who use paint, and especially by artists.

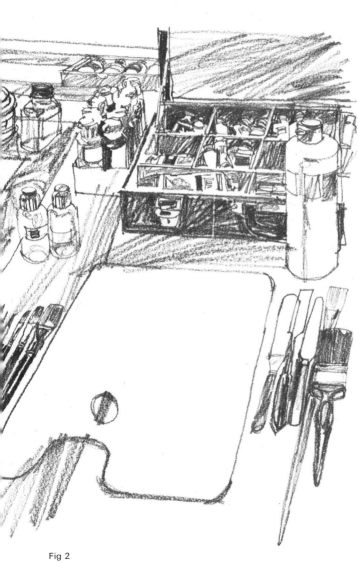

Fig 2

Fig 3

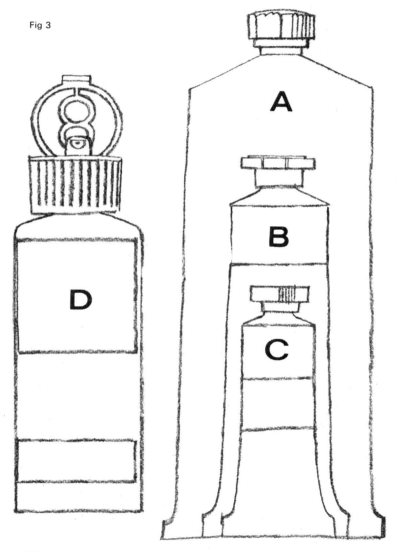

It is important to understand that when we talk of acrylics, we are referring to particular man-made substances whose structure is in the form of a chain of molecules (hence 'polymer') which do the same job as the traditional carriers, or vehicles, in that they contain and carry the pigments from which paint is made. They are plastic emulsions similar to perspex (Plexiglass) etc., and are milky-white when fluid and readily mixable with water, but dry absolutely clear and hard, while retaining elasticity and not becoming brittle. They are extremely strong and adhesive, give great brilliance of colour, and have many other advantages, as we shall see. The pigments in most cases are the same ones that have traditionally been used in watercolours, oil paints, tempera and so on. Some pigments however *are* new; and although they are also man-made, they can be used with either the traditional carriers or with the new acrylics. Sources of pigments are continually searched for, the ideal of the pure brilliance of the spectrum coupled with absolute permanence being the ultimate aim.

In order to clarify the position of the new pigments relative to the old ones, we should divide pigments into two main classes:

1 INORGANIC OR MINERAL PIGMENTS

These include ochres, raw and burnt sienna, and artificially-prepared mineral pigments such as cadmium yellow, zinc oxide, etc. All, or nearly all, these traditional mineral pigments are also used with the new acrylics.

2 ORGANIC PIGMENTS

This class includes animal and vegetable pigments (not extensively used now in traditional media, and not at all in acrylics) and the important and proliferating range of artificially-prepared organic pigments. These pigments are prepared in the laboratory by actually fabricating new substances which do not occur spontaneously in nature, and must be termed artificial. This term should be no adverse reflection on their permanence or purity, indeed artificial-pigment-based acrylics are now available from reputable colour manufacturers which are almost exclusively permanent and stable. Those especially that have names coupled with quinacridone, phthalocyanine, napthol, azo, for instance, are also extremely brilliant and have very beautiful depth and purity of colour. It is to these artificial organic colours that we must look for the really exciting additions to the ever-closer approximation of pigment purity to that of light.

Fig 4 Acrylic medium in squeeze bottle

In the meantime, we as artists should make the most of the many types of paint available. A choice has to be made. All manufacturers of paint for artists use varying amounts of 'extender' in the paints. This is an inert, colourless or white substance, which dilutes the strength of the pigment and is used either to extend the storage life of the paint or to make a very strong pigment more manageable; or sometimes to reduce the cost of manufacture. Too much extender reduces the colour strength and the usefulness of a pigment. When buying colour, one should view with the utmost suspicion a range of paints all of which have a pastel, pale or cloudy look about them. We need strong, pure colours – pale tints can be made by mixing with white on the palette, but a weak or extended colour can never be made strong again.

On page 10 (Fig. 3) there are actual-size drawings of the more usual sizes of tubes of paint. Large quantities, as A, are usually only for white paint, which one tends to use more than any other colour. Tube B is a useful average size for most other colours, bearing in mind expense and portability. Many designers' colours are made in smaller quantities, as tube C, but these are not usually acrylic paints. It is useful to have some of these smaller tubes, especially of the stronger colours. As explained later (page 29), they can be mixed with acrylic medium when painting, and thereby take on similar characteristics to actual acrylic paint. One has to balance the advantage of large tubes of colour, which are more economical and encourage freer use, against the compactness and portability of a large range of smaller tubes. The scale of the work embarked on affects one's choice of course, and it is best to discover by practice which colours one uses most of, and what quantities are sufficient and manageable. In general, earth colours have less strength and have to be used more lavishly than the strong-hue colours, such as prussian blue and phthalo-cyanine blue and green for example. D on Fig. 3 shows a squeeze-bottle of the size in which some acrylic mediums (page 13) are dispensed. Acrylic colours pre-mixed to a flowing consistency (for designers and illustrators) are also sold in these plastic bottles,

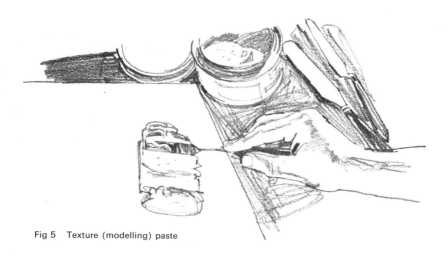

Fig 5 Texture (modelling) paste

the colour being squeezed onto the palette or directly onto the painting as one needs it.

Mediums

Mediums are available in three forms, all of which can be mixed with acrylic and non-acrylic watercolours. They are

1 GLOSS MEDIUM

This is fluid and milky but dries clear and glossy.

2 MATT

This, as one would expect, is the same, but dries without such an obvious gloss.

3 GEL OR 'GLAZE' MEDIUM

This is in gelled form and does not therefore flow or run on the painting. It is very valuable for making strong-hue transparent colours into even more transparent clear glazes. (This is explained later, in Underpainting (page 42) and Glazing (page 55)). A bottle of either gloss or matt medium, and a tube or a bottle of gel medium, should be considered essential.

Texture paste or modelling paste, made from inert aggregate such as marble dust, mixed with acrylic resin, is for building up heavy impastos and areas of texture which dry quickly and can be overpainted. It is sometimes brushable, but is usually of a consistency which must be applied with a palette knife. Perhaps it is not an absolutely essential material, but it is very useful on occasions.

Fig 6

Brushes

House-painting brush (natural bristle or nylon), about 1 in. or larger. Very useful for applying priming coats of medium or white, and for use in broad areas of the painting.

Fig 7

Nylon, $\frac{1}{2}$ in. and $\frac{3}{4}$ in., flat. Very hard wearing. These brushes spring back to shape even after standing in a jar of water overnight. Specially developed for use with acrylics; useful for applying large paint areas.

Pure sable, $\frac{3}{8}$ in., $\frac{1}{4}$ in., $\frac{3}{16}$ in., flat, long-haired (sign-writer's one-strokes). These brushes are more expensive and not so hard-wearing as nylon, but have the good shape and spring essential in these smaller brushes (Fig. 8).

Hog-hair (bristle) brushes are also suitable of course, although I personally prefer nylon and sable brushes.

Fig 8

On page 14 all the brushes are drawn actual-size. They represent what I consider to be about the minimum range of brushes and palette knives to cope with average-size paintings, say up to 20 in.×30 in. For larger paintings or murals, it would be better to have a greater selection of large brushes. However, I see no reason to use anything smaller than a No. 2 round brush, even for the most minute, precise work. A good brush has a fine point, and one needs some body in the brush to hold enough paint. If in doubt always use a *bigger* brush than you first thought of. Buy good brushes, and take care of them.

On the right, two types of palette knife, for use in painting and scraping, etc. The square one is flexible and very useful for applying paint in a precise, sharp-edged way.

Below, pure sable brushes, round, Nos 2, 3 and 5. For drawing into the painting, and applying fine strokes where needed.

Fig 9

Colours

Before listing the colours that I think you will need, I want to talk a little about the theory of colour.

White sunlight is composed of a range of radiations which are all the visible colours of light. This range, which is revealed when light is refracted through a prism, and is normally listed as red, orange, yellow, green, blue and violet, is called the spectrum (strictly solar spectrum). It is this package of colours which determines the colour of everything we see in daylight. Every substance absorbs some of the colour of the daylight falling on it and reflects the rest, and we see the reflected colour as *its* colour. If no light falls on an object, it has no colour, and if reduced or differently-coloured light falls on it, then it will have a different colour. It is important to understand that *nothing* has a fixed, intrinsic colour; it depends on what sort of light is falling on it. Nowadays, when there are so many kinds of. light other than sunlight (which in itself has great variations in colour, dependent on time and place, etc.), an object can be many, many different colours in different situations.

On the facing page is a colour circle, which is a spectrum painted in steps and bent round so that the violet end meets the red end in a purple. Purple does not really exist in the spectrum, but it is the result of mixing red and violet, and completes the circle neatly. You will notice that each colour in this circle is the result of admixing its neighbours on each side, and in theory only three of the colours would be necessary to mix all the others. These are called primaries, and are marked on the colour circle by the letter P. In practice, it is not always easy to mix really pure, clear colours from these three, because the pigments are never 100 percent pure, although some of the modern ones are very nearly so. The colours marked with the letter S are called secondary colours, and are a mixture of adjacent primaries and form complementary pairs with the primaries opposite them. In fact all the colours opposite each other in the circle are considered to be complementary to each other. Complementary colours always contrast strongly with each other, sometimes so strongly that they appear to vibrate. Red and green show this phenomenon most markedly, and certain oranges and their complementary blues do too.

You will perhaps have noticed that browns and greys do not appear on a colour circle. These colours do not exist in the spectrum, and only appear as colours of actual objects and substances. The colour of most substances, including pigments, contains a

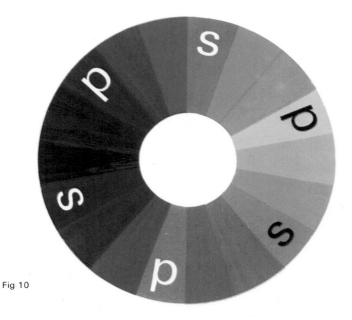

Fig 10

Fig 11

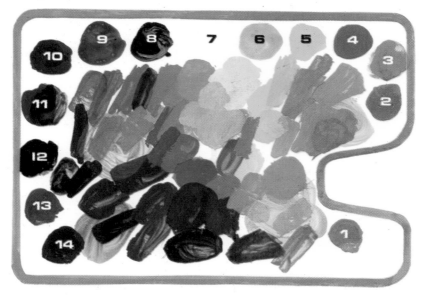

little black or brown, some a great deal; and the rich colours resulting from black admixture greatly extend the range of colours experienced beyond the spectral hues. Such colours are called 'shades'. Colours lightened by the addition of white are called 'tints'. To imitate any colour exactly using spectral hues (pure colours), black and white, one needs to get three things right:

1 the position of the basic hue in the colour circle
2 the strength of the hue, full-strength or weakened by white or black
3 the tone value – lightness or darkness of the colour – which is partly dependent on its hue (i.e. red is tonally darker than yellow, however strong), and also affected by the amount of black or white. Any colour can be matched by systematically getting these three factors right.

Assuming that an artist wants a set of paints from which any colour can be imitated, from the foregoing it is obvious that he must have, at the very least, the primary colours and black and white. In practice, to be assured of covering all the hues in the colour circle really adequately, one should have at least two more hues. A minimum working palette could consist of the following colours, numbered as they appear on the full-colour palette diagram on page 17:

1 rose or magenta – the most brilliant of these are made from organic lakes (i.e. a pigment made by fixing dye on an inert base), but the older types are very fugitive. The new quinacridone rose used in acrylics is permanent, although not quite so intense. Rose madder is fairly permanent, but not very strong.
2 orange-red – vermilion, cadmium red, napthol red
5 bright yellow – cadmium yellow, hansa yellow or similar
9 green-blue – phthalocyanine or monastral blue is good. It can vary from green-blue to blue-green
10 cold pure blue – ultramarine is ideal
12 black – usually iron oxide or mars (the same thing)
7 white – titanium white is the most opaque, but has a slight yellow tinge. Zinc white is a blue-white and seems to make slightly cleaner tints, but does not cover so well.

Although every colour could be mixed from the above, it is easier to add a few more excellent pigments to the working range

3 orange – cadmium orange, mars orange, orange lake
4 raw sienna – an old, beautiful earth yellow
6 lemon yellow
8 green – viridian, phthalocyanine green

11 Violet or purple – dioxazine purple, cobalt violet, mars violet. Any really vivid mauve

13 raw umber – another earth colour which is very useful

14 burnt umber – very dark and rich, calcined version of above.

All these pigments are shown on the palette on page 17, in the order that I set them out. It is important to have some system of palette layout, which should be adhered to as a matter of habit, even if only a few colours are being used. My layout, loosely based on the spectral order, has white in the middle with warm colours radiating from it one way and cool colours in the other direction. I define warm colours as the reds, oranges, yellows, and yellow-greens; and cool as the blue-greens, blues, violets, purples and magenta. The magenta primary is free from any trace of yellow and therefore cool, but I keep it with the other reds for coherence. Also the earth colours are a little difficult to place: the siennas seem to belong with the warm yellows, and the umbers I put next to black, although raw umber is strictly a warm colour.

The mixing areas then divide naturally into classes of colour adjacent to their components, so that without special thought the hues which tend to get together in the flurry of painting are those which make clean, rich mixtures. Complementary pairs when mixed together, as distinct from being *placed* together (which produces dazzle, as previously mentioned), tend to make grey, rather muddy colours. In this layout they are well separated, as are black and white, which avoids mutual adulteration of tints and shades.

In use, the longer the palette-mixing areas remain under control, the better. Obviously, when involved in a painting one can't be *too* concerned with the palette, especially if things are not going too well, so a natural, habitual order, which one knows without looking, is a great help.

The sub-division of the palette into cool and warm areas is also helpful. It is strange that this matter of colour temperature is so often ignored or misunderstood. The abstract organization of a painting is helped considerably by the conscious grouping of warm and cool colours, so that one temperature or another dominates; and a sudden contrast of warm against cool provides as much drama as dark against light.

When mixing colour, great care should be taken with the addition of black or white. If a dark, rich shade is required, which has become excessively dark by admixture of black, avoid using white to lighten it, as it will immediately go grey and opaque. Either add more of the original hue, or modify it by adding a

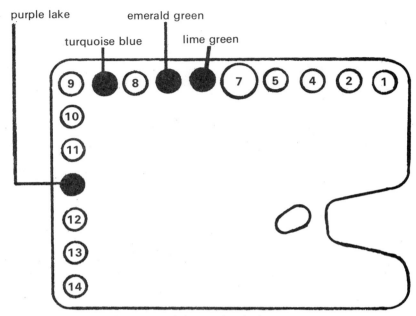

purple lake emerald green

turquoise blue lime green

Fig 12 Palette layout – extended range of cool colours

tonally-lighter hue, or start again. Let me give an example. Suppose one wants to mix a dark olive green. A yellow-green hue should be chosen and a little black admixed. If too much black is added, do not add white to counteract it, but add more of the original hue, or some brilliant yellow. If it still remains too dark, as it may do, because black can overpower yellow very easily, it may be easier to make a new mix. Conversely, mixing a pale tint should be carefully controlled so that balance between white and the hue is right, black only being resorted to when one is certain that the hue and saturation are right but that the tone value must go down.

Of course, many good colours can result from the direct mixing of pure hues, without the use of black or white. The possible combinations are too numerous to list, but it can be very profitable to discover some of them yourself by experimenting.

When composing a painting with either cool or warm colours very dominant, it is sometimes useful to extend the pigment range in the appropriate direction. On these pages are two further palette layouts. The left-hand palette shows an extended blue-green range, which will give a great deal of subtle, closely-related harmony if handled with care and invention. All the extra blues and greens could be approximated by mixing from the normal range,

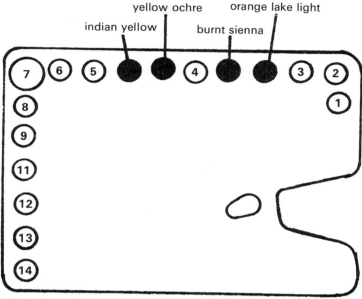

indian yellow yellow ochre burnt sienna orange lake light

Fig 13 Palette layout – extended range of warm colours

but it is difficult to achieve quite the clarity of some of these subtly-differentiated pigments. An extended range of reds and oranges, as on the right (Fig. 13), can be even more difficult to match in brilliance by normal mixing, so in certain cases it is an advantage to use such a specially warm palette. However it is not entirely essential to have so many paints, and obviously too many will make one's equipment unwieldy and expensive. Start with the normal range and discover your individual colour preferences. There is absolutely no reason why you should not paint entirely in one colour, or only in black and white, as long as it is done with honesty and give you pleasure.

A box for the paints is an advantage when painting in the studio, and an essential outside. The drawings on pages 22 and 23 show how to adapt a case for this purpose, and there is some further explanation on pages 70 and 71. There are, of course, many complete paint boxes on the market.

Grounds and supports

There are many preparations available for priming canvas or board for painting with acrylics – although in most cases there is no need for a special preparation. An absorbent surface is usually

Fig 14 Partition construction

adequately sealed by a coat of acrylic medium (either matt or gloss), and, if more bulk or brightness is required, this can be followed by a coat of acrylic titanium white or of a prepared acrylic ground. Even an oil-based ground can be painted on, although some roughening of the surface with sandpaper is desirable to ensure easy initial adherence.

Nearly all paper and card (cardboard) is suitable for painting on, and I particularly like highly-glazed (or coated) printing paper. The slipperiness of the surface makes every brush stroke visible and exciting. If flat washes are desired, avoid very smooth surfaces. Any paper with a 'tooth' is fine, but of course if it is too thin it will absorb water, expand and cockle (buckle) when painted on. This can be avoided by stretching or mounting on a board of either wood or heavy cardboard. Stretching the paper can be done by soaking thoroughly and taping securely with gummed strip (adhesive tape) to a rigid wooden board. When the paper dries and shrinks, it is effectively proof against further cockling (buckling), and can be detached from the board when the painting is finished.

Another way, and in my opinion a better one, of preparing paper for painting is to mount it permanently on cardboard. At least $\frac{1}{8}$ in. thick cardboard should be used, and the paper can be mounted with a variety of adhesives. Plastic, wallpaper-hanging paste is good, and should be brushed liberally on one or both sides of the paper and the cardboard; the paper is then applied to the cardboard and the wrinkles eased out with the hand from the centre. The paper is mildly stretched by this method, and when it dries the cardboard will tend to curl. To avoid this, either weight it while drying, or paste paper on both sides of the card in order to equalize the tension. Contact adhesives can also be used to mount paper, which have the advantage of being used dry. Great care must be taken, when applying the paper, to avoid

22

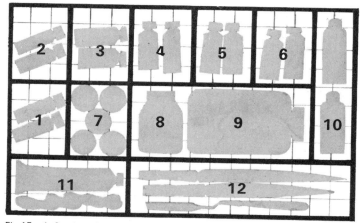

Fig 15 1–6 paint tubes grouped according to colour; 7 coloured inks; 8 texture (modelling) paste; 9 water; 10 mediums; 11 white paint and paint rag; 12 brushes, palette knives, pencils etc.

air bubbles. Hold the paper so that the centre touches first and press down firmly and gradually to the outer edges. Thermo plastic dry mounting tissues and fluid which adhere when the paper is ironed onto board are also available, chiefly from photographic suppliers.

The palette has been frequently mentioned, but for painting indoors a hand-held palette is not strictly necessary. Any smooth, preferably white, surface can be used, but it should be as large

Fig 16

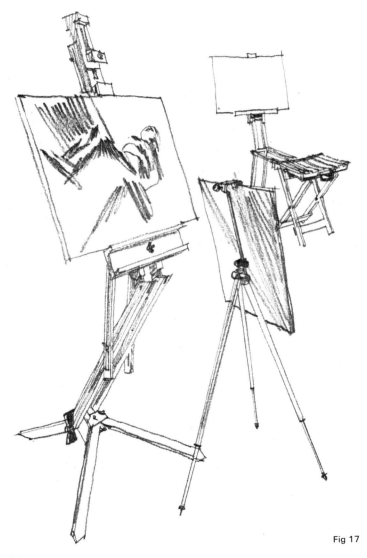

Fig 17

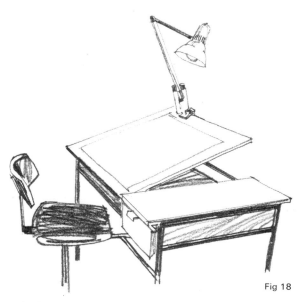

Fig 18

an area as practicable, and easily cleaned. Plastic, white-enamelled metal, a marble slab or plate glass over white paper are all suitable for use as a palette and will stand up to the cleaning necessary to remove the hard-drying acrylic paints. One advantage of a portable palette is that it can be immersed in hot water in the sink, which softens the acrylic film, allowing easy removal with a palette knife. Alternatively, disposable paper palettes are available in pads at most art shops.

An easel is not absolutely essential indoors for small paintings, but if work above about 20 in. × 25 in. is undertaken, it is difficult to view it in its entirety without propping it up on something. Oriental painters, and more recently tachists (action painters), produce very large paintings without ever moving them from flat on the floor, and if the paint used is very fluid it may be essential to keep the canvas horizontal or nearly so. A work desk, with a top which can be sloped, is ideal: something like mine, which is illustrated above.

For large paintings with viscous, non-runny paint, and for any sort of painting outdoors, one needs an easel. The first requirement of a good easel is that it holds a large painting rigidly at the proper angle. Secondly it should adjust easily and simply. Any other extras, such as being able to convert it into a table, or attach a paint tray, etc. are useful, but subordinate to the first two requirements. For outdoor use, additional essential attributes are lightness and compactness.

25

2 Line and wash

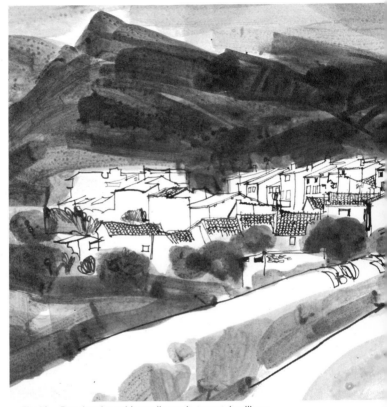

Fig 19 Pen drawing with acrylic wash, mountain village

The most useful quality of acrylic colours is their very short drying time, allowing several coats of paint to be applied quickly. This would not seem to be a particular advantage for line and wash drawings. Indeed, although it is quite possible to use acrylics for traditional flat washes, such use reveals no special advantages over watercolour. The attraction of the medium as a wash lies in its own particular and unique qualities.

In general all acrylic washes tend to be textured, with brush strokes clearly visible, and varying degrees of light glowing through from the white paper or ground. More water admixed and gentle application generally produces flatter washes, whereas

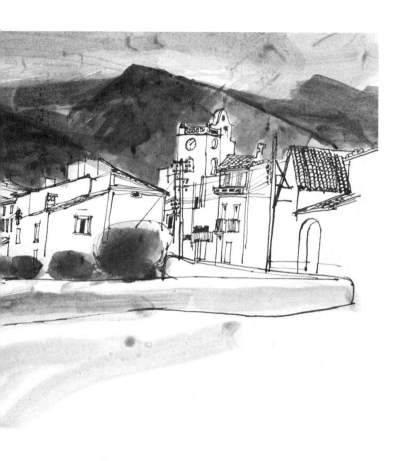

more medium (matt or gloss) and vigorous mixing and application produce the opposite extreme – bubbly and highly textured.

I will try to describe simply the many technical effects available from various admixtures.

1 ACRYLIC COLOURS PRE-MIXED IN TUBE

With plenty of water added these will give fairly flat washes if wanted; but used solidly, without the addition of medium, they usually cover well and dry fairly flat. The addition of more medium makes for greater transparency and more texture.

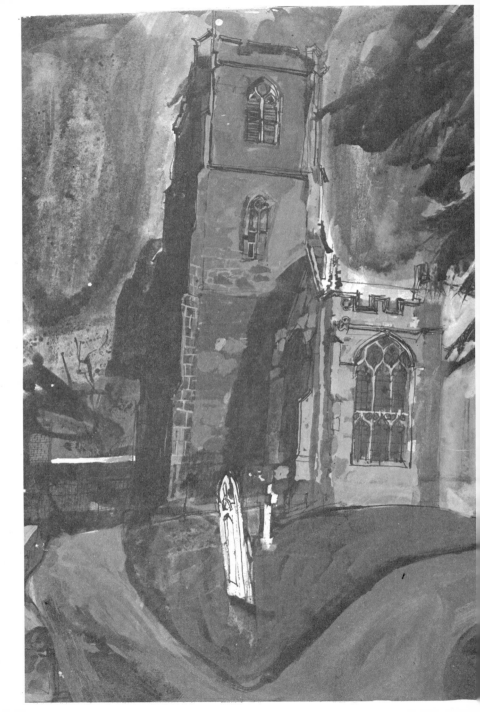

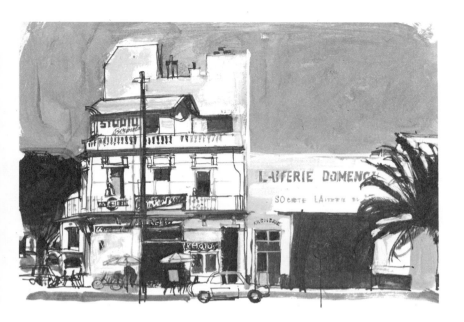

Fig 21

2 ILLUSTRATORS' COLOURS

These are pre-mixed into a liquid, free-flowing consistency, and with additional water can be used in a very free and 'washy' way. Probably these will give the nearest to traditional watercolour washes. Used on their own, or with additional acrylic medium, they become more slippery and transparent.

3 GOUACHE, OR DESIGNERS' COLOURS, WITH ACRYLIC MEDIUM (EITHER GLOSS OR MATT) ADDED

A great range of texture is available when acrylic medium is added to non-acrylic watercolours on the palette. If a small amount of medium is dropped into a pool of colour already diluted with water and gently mixed, a wash will be produced which is similar in quality to normal watercolour but partially or wholly waterproof, and therefore impervious to subsequent over-lying washes. There is no effective difference in use between gloss and matt medium, it is a question of which finish you want. More medium, gently added, produces more transparent colours; and if used with bright lakes, such as viridian lake and bengal rose, and organic pigments such as phthalocyanine and quinacridone, fantastic brilliance results. These modern pigments, with their great strength and staining power, can be considerably diluted

Fig 20 Coloured inks with acrylic medium and wash, church

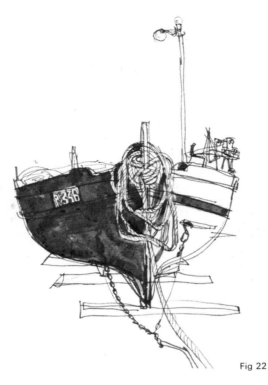

Fig 22

with medium without becoming pale in hue, and the effect of a white ground glowing through them can be quite remarkable in its brilliance.

4 GOUACHE, OR DESIGNERS' COLOURS, WITH GEL MEDIUM ADDED
Similar effects to 3 will be obtained, except that the gel medium is much thicker than ordinary medium (matt or gloss) and will not froth as much. Also, a large proportion of medium can be mixed with a small amount of pigment without the mixture becoming 'runny', even to the extent of becoming almost completely transparent with only the faintest tint of pigment. Such a glaze scarcely qualifies as a 'wash' and the special effects of multiple glazing are discussed more fully on page 55. Gel medium dries glossy, but not as much so as gloss medium and is chiefly valuable for its non-running properties.

As to the subject of this chapter, line and wash, any of the foregoing techniques can be used to supplement a line drawing, or have a line drawing added to them. Adding a line drawing can be a

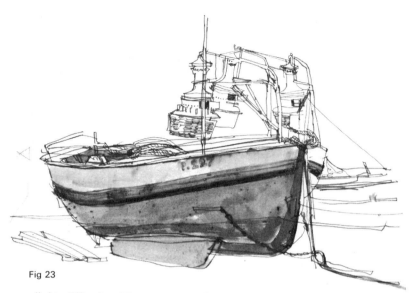

Fig 23

slight difficulty. The more acrylic medium the colour contains, the more difficult it is to draw on it with many of the traditional line materials. Pencil, for example, just slides over the highly-glazed plastic surface of a wash that is rich in medium. If the glaze is hard dry, pen and ink may be persuaded to flow on it; but most inks tend to slide and not to adhere to the plastic surface. Worse still, if the wash is not hard enough the pen will cut in and become clogged. The addition of a few drops of acrylic medium to the ink may help things, but be careful, as too much will just dry and clog on the pen.

Felt-tipped or fibre-tipped pens will mark readily on acrylic washes, but mostly they are non-waterproof, and so any further washes on a drawing made with these pens will result in running or obliteration of the line work already applied.

Certain Chinagraph (china markers) or waxy pencils will mark on acrylics, and they have the advantage of being impervious to further washes, but they are usually fairly coarse and difficult to handle.

Brush line, using acrylic paint, or paint or ink mixed with a little acrylic medium, is very satisfactory, provided that one is reasonably competent at using a brush for line drawing. A good quality, smallish brush (round sable, No. 2, 3 or 4) in good condition should be used for drawing with, and it is usually best to hold the brush vertically with the paper horizontal, i.e. at right angles to the drawing. There is no rule about this of course, but the very beautiful brush drawings of the East, especially of the Chinese, are produced in this manner, and it does seem to give the best control.

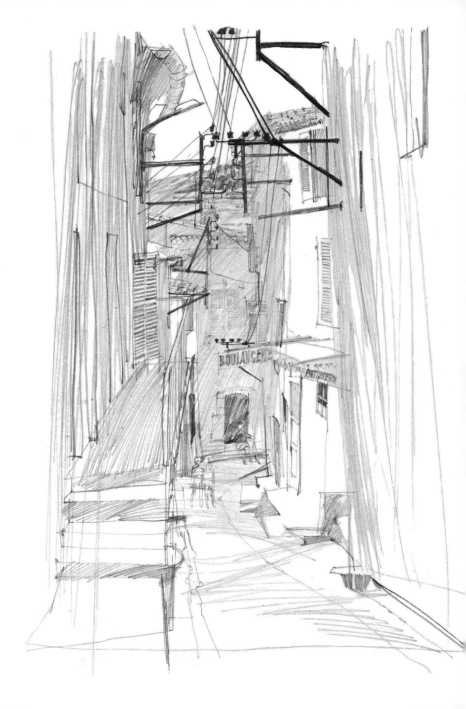

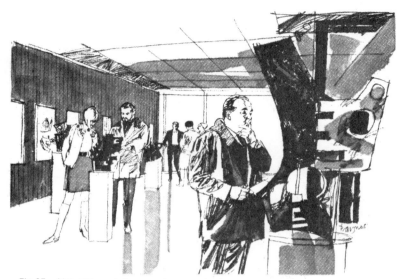

Fig 25 Line and wash for magazine reproduction

To my knowledge there is only one exception to the difficulty of marking with pencil, pen etc. over acrylics. This is an *oil-miscible* acrylic paint which, when dry, provides an excellent hard base for pencil drawing. However, it is rather like true oil paint, in that oil mediums have to be used, and although the drying time is comparatively rapid, it is still longer than water-miscible acrylics. Such paints require techniques similar to oil painting, and as such are not within the scope of this book.

In view of these complications, it is usually easier to (1) use very little medium in the first washes, add line, and then glaze; or (2) draw first, and add washes afterwards.

If procedure (1) is followed, the initial washes and shapes should establish the compositional idea, dividing and allocating space in the picture area, and perhaps establishing some of the main tones. The less medium there is in the washes the easier it will be to mark with a pencil or pen, so watery first washes should be aimed at, the high gloss glazes being saved until later. In either case most drawing mediums can be used.

Drawings made with graphite pencils, wax pencils, indian ink or anything not too easily smudged can be overlaid with acrylic washes without difficulty, indeed pencil drawings will be permanently fixed by such washes. Remember though that all non-waterproof drawing mediums, such as most felt-tipped and fibre-tipped pens, will run and blur when water or acrylic washes are added. Even spraying pastel fixative or pure medium to fix the

Fig 24 Pencil drawing

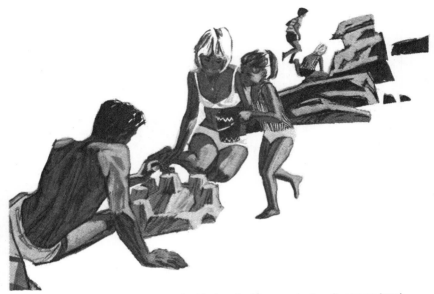

Fig 26 Monochrome greys for black and white reproduction, figures on beach

drawing will make the line run. Nevertheless if the first layer of
medium is applied very sparingly, a slight blurring will occur
which is not unpleasant, and subsequent washes will be unaffec-
ted. The sketches on pages 30 and 31 were made with a bamboo-
tipped pen. The tonal areas were then treated with a quick light
coat of clear acrylic varnish, and acrylic washes applied on top.
N.B. Felt or fibre-tipped pen drawing on coated paper (i.e.
papers with a thin layer of China Clay to produce a very smooth
surface) is instantly absorbed by the coating and will not run.

It is appropriate at this stage, I think, to discuss some general
principles of drawing. If an amateur, the reader will start with the
advantage of more or less complete freedom from any of the
influences of established styles of drawing. Perhaps there will be
some influences from popular paintings seen in the windows of
art dealers, but in general try to turn your back on these and ap-
proach every subject with your own observation. If you *must*
imitate any one, make sure that it is an established master. Such
may be difficult to define, and it would not seem too profitable to
attempt to draw in this age like Leonardo da Vinci, for example.
With the utmost caution I would suggest that the most modern
draughtsmen and painters of acclaim that you honestly appreciate
and feel in sympathy with, may be the ones to imitate, if any.

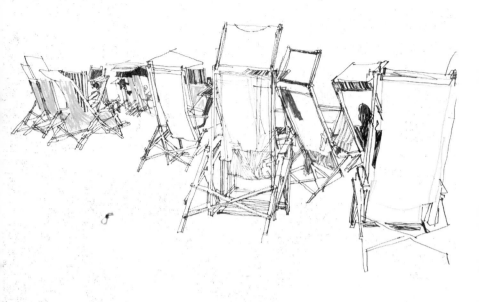

Fig 27 Drawing with coloured felt-tipped pens, beach chairs

It is very necessary, when drawing objectively, to decide what particular aspect of the object is most important and attempt to describe this as accurately and economically as possible. By objective drawing, I mean drawing which is an attempt to describe or say something about a *thing*, be it a tree, a cup, a landscape, a person, or even a reflection or a shadow. It is objective, in that the object is in front of you, and direct observation of it leads you to put down certain lines and shapes on paper. The point is that although these lines and shapes will be the direct result of careful observation, they may take many forms and present many different aspects of the observed object. The outside shape, the silhouette of a figure for example, may be what interests you, perhaps the pattern made by a group of figures together, or again the impression of sheer solidity and weight of a rock, or the roundness and volume of an apple against the flatness of the surface it rests on. Maybe it will be dramatic contrast of light or subtlety of closely-related tones. Whatever in the object seems to be most important and characteristic, this is what your drawing must clearly show. Too much said, too many aspects of an object described, with none dominant, will dissipate the message, no one will be interested in it. You must show what interested you enough to want to draw it in the first place.

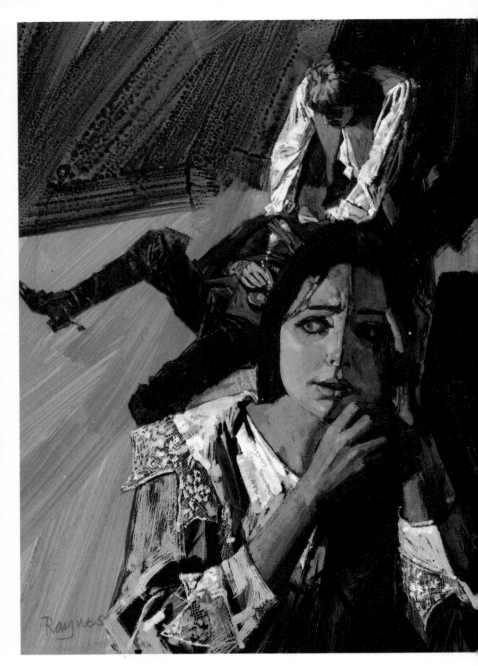

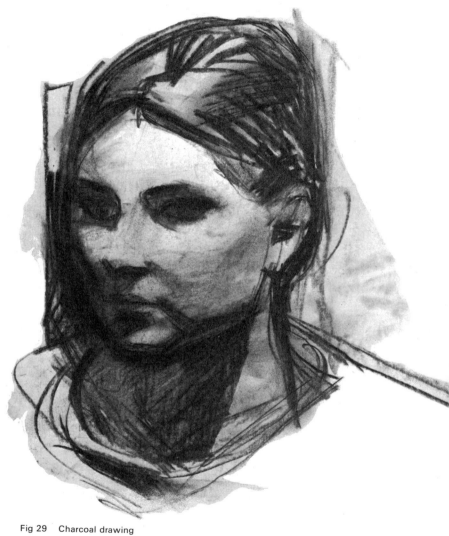

Fig 29 Charcoal drawing

Fig 28 Acrylic painting for book cover, *Lorna Doone*

Fig 30 Felt-tipped pen drawing

So drawing is at least as much a matter of attitude as of skill, although of course certain of the traditional studies, such as anatomy and perspective, can help one to see more clearly, and practice will make one more able to put down what one sees. A drawing can also be thought of as a record of discovery, i.e. as the drawing progresses, more and more is discovered about the object. When you prepare to draw, try to look at the object as though you have never seen it before, however familiar an object it is, and try to see first its whole shape, and how it sits relative to its surroundings. A head is a good example, because one tends to think that one knows what it looks like, whereas in fact the objective reality is usually covered and hidden by many subjective ideas, such as 'he has kind eyes', 'she has a sour expression' etc. Such characteristics of personality *are* important in a portrait of course, but they are *surface* happenings. The structure and deeper character of a head will only be discovered by looking carefully at the larger shapes, the spaces between the features, and by trying to sense the volume. The drawings in Figs 30 and 31 show how one can find planes (sort of hypothetical flatnesses in space) which lie across, and in a way link together, groups of forms.

Fig 31 Chalk sketches from life

Similarly, the walls of buildings are planes with horizontal edges appearing to converge at a vanishing point on the horizon. The three most useful facts of perspective are:

1 All parallel lines appear to converge and meet at the same point (Fig. 32)

2 A square or rectangle in perspective is divided by its diagonal. This fact allows one to halve any dimension on a wall in space, and therefore of course, also to double it (Fig. 33)

3 A circle in perspective is an ellipse, the 'major axis' (AB, Fig 34) of which is always at 90° to its 'axle' (CD). If the circle represents a wheel, and the ellipse is the wheel in perspective, the 'axle' will be the shaft.

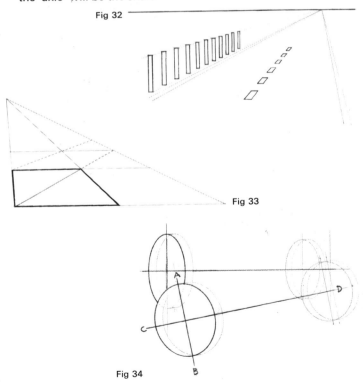

Fig 32

Fig 33

Fig 34

Fig 35

There is much more to perspective than this of course, but it needs a chapter or a book to itself. Careful and intelligent observation will tell you a great deal, and a total disregard for the laws is not always a bad thing. For example the flat pattern of a series of streets and houses may be more important to you than the fact that they recede in space – if so, by all means draw them as though they were on a flat plane. As long as it looks as though you really mean it and that you are not just being careless or inept in an attempt to draw 'correct' perspective, then the point and purpose of the drawing will be clear and self-sufficient.

3 Underpainting

Fig 36

Everything that precedes the final surface of a painting is underpainting. Before embarking on how to paint an underpainting, perhaps we should consider what an underpainting should comprise. Initially therefore I propose to discuss composition.

A painting, unlike one's vision, has a positive edge, a sharp cessation, usually further accentuated by a frame.

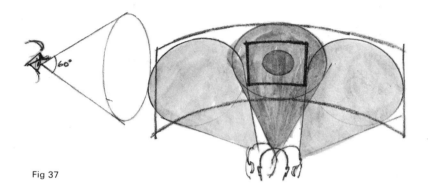

Fig 37

One's own vision is more dispersed. There is only a relatively small area in the centre of human vision that is really sharp. Outside this circle, focus is slightly more diffuse, up to an area which is known as the 60° cone of rays, see Fig. 37. After this comes peripheral vision, in which we are conscious of movement but cannot be explicit about shape. This means that one's vision has a focal point. It is the vision within this 60° cone which is amenable to the system of explanation which we call the 'laws of perspective'.

In composing a picture we usually take a part of this single vision area, and bound it by a square or rectangle, so that it can be seen in total. Since the painting will be viewed at a distance which will allow it to be seen in entirety without moving the head, the area of observable reality that is chosen to be painted is similarly viewable without needing to turn the head. It *is* possible to encompass more – and to draw what is seen as one's vision sweeps round in an arc, even to complete 360° rotation until the horizon joins up. Such a drawing, though fascinating to do, rarely has one compositional idea – it is like a series of compositions joined together.

Any long painting extending far out of one's single view, either upwards or sideways, will tend to be like several compositions joined together, and it is a first principle of good composition that only one basic compositional idea is dominant.

So I propose that we now consider the rectangular picture that we are to extract from our basically-circular vision.

It is sometimes helpful to view your subject through a small window cut in a sheet of paper, the window being the same shape as the proposed painting.

Let us suppose that one is facing the landscape depicted on

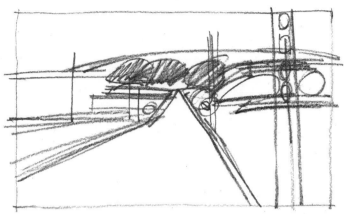

Fig 38

page 69. Hold the paper mask up so that the landscape is seen through it. Note where the horizon divides the rectangular shape, and how the simple masses are distributed within the area. Move the mask towards you (seeing more of the landscape) and away. Try to decide which is the visual centre, and how much of the sur-roundings is necessary to make interesting shapes which lead the eye to the visual centre. A viewpoint slightly to the left of the one chosen by me would have shown a composition something like Fig. 38. I felt this to be a little ordinary and unexciting, the perspective being rather symmetrical and the distant rise in the road not obvious for what it was.

Moving closer would take the viewpoint lower into the dip in

Fig 39

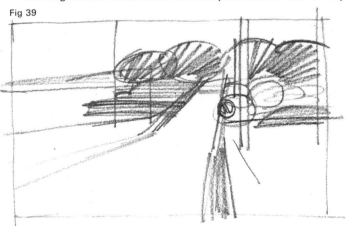

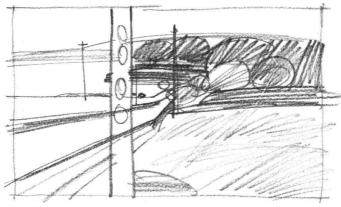

Fig 40

the road, and thereby drop the horizon lower behind the far trees, giving a composition something like Fig. 39. A position to the right would move focus away from the road and sea entirely and be primarily a landscape (Fig. 40). Fig. 41 is an analysis of the composition actually decided on.

What I want to stress is that none of these alternatives is necessarily good or bad. The rightness of a composition depends on its fitness for the intended purpose, which may sound obvious, but is not always realized. Put it another way: the composition you choose depends on what you want to say about what you are seeing. In the case we have been discussing, the road by the sea (which incidentally was only a quick, one-hour sketch), I wanted

Fig 41

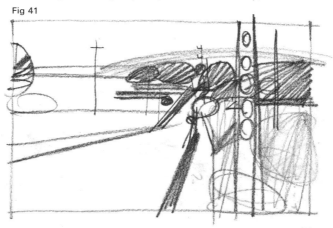

to record how the straight ribbon of sunlit road dipped and rose again and divided the flat sea from the undulating land. The perforated telephone poles, with their strong verticals, stop the eye from wandering about, and give recession, which leads one up the road, over, and into the bank of trees. This was what *I* liked about this view, other people will react quite differently no doubt, and there will be many other aspects of the same landscape which could be stressed.

The problem is slightly different when a composition is to be evolved from imagination. I have not previously mentioned compositional balance, which is felt, rather than calculated. There exist measuring systems which can be used to divide and subdivide according to an abstract ideal of proportion, but they are fairly complicated and used more by architects than painters. Usually painters rely on a much more intuitive trial and error balance. Obviously absolute symmetry is entirely balanced and calm (Fig. 42), but if the intention is to be more exciting, the fulcrum has to be moved somewhat nearer to one edge and weight increased on the short side. A blank, restful area can be balanced and made to work by a small, bright area of colour or complexity close to, but just the other side of, a centre of attraction (Fig. 43).

Fig 42

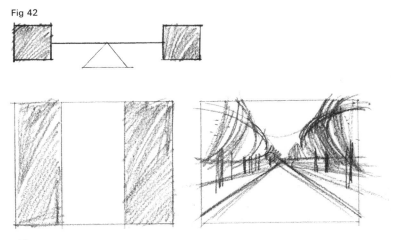

In the composition of an imaginative subject there are no restrictions and no guidance from a real scene, and the best way that I can demonstrate the sort of choices which have to be made, and suggest one possible working method, is to analyse an existing composition. Fig. 44 on page 48 shows the first basic compositional idea of the figure illustration reproduced in full colour on pages 62–63. The requirement here was to present a group of a minimum of twelve young people involved in an instantly-recognizable activity, in this case the organizing and hanging of an exhibition of paintings. The illustration was for use in an advertisement, and had to be bright and arresting in colour and composition. In order to have some large, relatively-flat areas to counterbalance the necessary complications in the centre of interest, I attempted to keep the figures mostly clustered together in one area of the picture, and kept the eye level (and therefore horizon) high, so that the background formed a sort of decorative but inactive frieze.

In the next stage the centre of interest in the form of the red, striped abstract painting was fixed a little to right of centre, and the grouping of figures arranged to lead to it. This movement was accentuated by the back of the painting breaking in from the

Fig 43

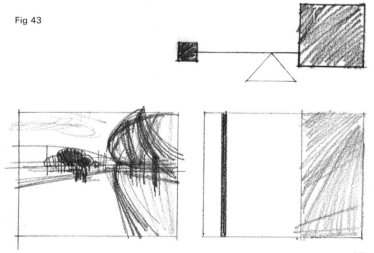

bottom of the picture, but to avoid the eye going straight to the red painting, which would be a little too obvious, a secondary centre was created by the convergence of interest of the foreground figure group.

In professional advertizing illustration there are always considerations other than aesthetic ones of course, so that the end result is frequently a compromise between many, sometimes conflicting, requirements. Painting an easel picture you will have no such restrictions, and groups of figures and objects should be grouped and rendered in the simplest, most forceful way for maximum impact.

The roof at the top right, while giving recession to link with the background, was also designed to assist in leading to the centre of vision. To keep the colours within the main group of people to a generally warm, closely-related range, and yet provide clear differentiation between them, patterns were introduced on the girls' dresses. The blue shirt in conjunction with the gold-patterned dress was also intended to provide a secondary subjective centre. The white upright, AB, was put there firstly

Fig 44 Composition plan of colour plate on pages 62-3

because it seemed to make a nice interval in what is rather a wide shape, and also to help the illusion of real-life, in which one's view is rarely complete and unobstructed.

As I said, everything that precedes the final surface of a painting is underpainting. Preliminary drawing is part of it. Let us once and for all get rid of the idea that drawing is something that is done first in charcoal, on a canvas.

I can see no point whatever in first delineating everything with black charcoal marks, which have to be sprayed with fixative, and rarely help very much in establishing the composition. It is all right if only the main compositional lines and masses are indicated, but why not use a brush with colour for the same purpose? It is true that charcoal can be eradicated easily; but if your preliminary drawing is limited to compositional construction, there is no need to rub out, as *all* the constructional lines are of value, if only to establish markers of wrong decisions so that right ones may be made. I do not wish to denigrate charcoal as a drawing medium in its own right. It is, of course, an excellent medium for making tonal studies, from which one may later paint.

Let us now consider other ways of beginning a painting. Firstly, it must be realized that parts of an underpainting can be left untouched in the final painting, and one should be constantly alert, as the painting proceeds, for passages which are satisfactory in themselves and therefore better left unmodified. Thus at one extreme all the underpainting may be visible, either directly or through a transparent film of paint (called a glaze), and at the other extreme the underpainting is almost totally obscured by opaque paint. It is important to have some idea what sort of second-stage painting is intended before embarking on a particular underpainting procedure.

To try to rationalize the great diversity of possible underpaintings, I intend to describe five fairly well-established techniques.

1 Single key colour

The initial application of one colour over the complete painting area is a technique often used today, especially in illustration. Such underpainting is usually a brilliant or rich transparent colour. As the painting proceeds, other transparent colours are laid over this basic colour. As a result, a great variety of colour and tone can be achieved, but since all the colours are a modification of the original one, they have an underlying unity or harmony. Thus the underpainting acts as a sort of 'key', which defines, and to a certain extent limits, the colour range of the painting. It is not always desirable to underpaint the key colour evenly all over the painting area, and it is essential that it is transparent enough to allow the original white ground to shine through it. Otherwise, of course, it would not be an underpainting at all, but a coloured ground.

An elaboration of this technique is to underpaint the key colour under selected areas of the painting only, or perhaps to use two or three different key colours.

2 Dark for paint-back

I am afraid I can't think of a better title for this technique. It involves the painting of the design in a very dark colour, maybe black, over all or most of the painting area, even where it is eventually to be light. The painting then progresses by the application of lighter, opaque colours, which largely, but not completely, cover the dark underpainting. This is called scumbling, and it is not easy to explain the advantages of the procedure. I will attempt

to do so, however, on page 58. For the moment I refer you to the illustration reproduced in colour on page 36. A large part of this was underpainted black or dark brown. The girl's face and dress, for example, was first drawn and delineated with black and dark brown paint, and the areas of light and shade alike all filled in with fairly freely-applied shades of black, so that it was only just possible to see a face there at all. The lighter areas were then dragged on, an effect especially clearly seen on the girl's dress.

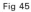

Fig 45

Fig 46

3 Thin to fat

This is a traditional method, well-known since at least the fifteenth century. Painting begins with transparent (thin) colours, which can be vivid and rich but which are designed to be the eventual shadow and dark tone areas. As the light areas are developed, the painter uses thicker and more opaque (fatter) pigment. The chief advantage lies in the fact that thin layers of paint can give every appearance of darkness and therefore represent shadow very well, while still allowing the underlying ground to glow through and illumine them. The thicker opaque pigments, which in this method are reserved for overpainting the light areas, can be of strong hue and do not need the light from beneath, but because of their thickness catch the light from without and give a very persuasive sense of solidity and form.

Although opaque paint with white admixed will be used in the later stages, it is essential in this underpainting technique, and in the two previous ones, not to use any white mixed with the colours. Transparency of colour is vital at the underpainting stage.

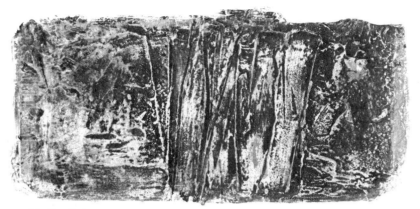

Fig 47 Texture

4 Monochrome

Many Italian masters used this next method, but perhaps its most famous and brilliant exponent was Peter Paul Rubens, the Flemish painter. A very complete painting in tones of grey alone is produced, with the intention of overlaying the final colour in transparent glazes.

The whole form and structure of the painting in terms of tone can be finalized in this way, without the complication of colour, but of course it takes experience and experiment to predict how it will look when the colour is added.

5 Texture

Acrylic paints are especially useful when painting a heavily-textured underpainting, as even very thick layers dry quickly. Such an underpainting differs from the previous ones in that it has *actual* form, rather than apparent form, and has its own particular excitement. By the use of a palette knife and texture (modelling) paste, most interesting textures can be built up in white or monochrome, which can appear very rich when subsequently glazed with brilliant or subtle colour. Do not apply the texture (modelling) paste in layers thicker than $\frac{1}{4}$ in., or cracking may occur while drying. Thicker layers should be built up from several relatively thin ones. Such passages provide variety, and would usually be used in conjunction with smooth areas of transparent or opaque pigment in a fairly abstract way. Try therefore to restrict the areas of very rough texture to where they'll do most good.

4 Alla Prima

Literally 'at the first', this term means painting in which each stroke of the brush on any area of the painting is the first and last. The idea is to decide what is to be the final colour and tone and try to paint it exactly so, without further modification and without any preliminary underpainting.

Acrylic paints are as good for this type of painting as any other colours, but have no special advantages. The normal advantages of quick drying, enabling succeeding layers of colour to be applied quickly, is of no value for Alla Prima. There is a certain brilliance in some of the strongest pigments when they are used fairly transparently (mixed with acrylic medium), applied decisively and left alone, which is very attractive. The very direct appeal of such colour is partly due to the glowing of white ground through it, but also, and probably mainly, to the white which partly or wholly surrounds it. An Alla Prima painting normally has a lot of untouched white canvas, because it is quite difficult to butt each colour to the next with precision; and this gives the painting a quality of verve and directness, each colour having a validity of its own while having at the same time to take its place in the complete composition. It is quite difficult to manage this successfully – all too easy either to go too far, so that the essential verve has gone, or to achieve directness with no cohesion, so that the composition looks disjointed and incomplete.

I must confess to feeling a little uncomfortable using the term Alla Prima at all. In these days, when painters are applying colour to paintings by a vast variety of means – including spraying, spilling, dripping, silkscreen printing, etc. – who is to decide in many cases whether a painting is first time or not? In a hard-edged painting, i.e. one in which areas of colour are designed precisely and defined sharply, house-painting enamels are often used, and may very well be applied directly and without further modifying. It would technically be Alla Prima, but in these circumstances it is a meaningless distinction. Only when referring to paintings in which brushes, palette knives, and so on are freely used to express some interpretation of objective reality, does the term have any real meaning. Let us leave it there.

5 Glazing

In this context a glaze refers to any transparent or semi-transparent paint layer. The successive application of more-or-less transparent glazes is an established technique in traditional watercolour painting. Acrylic glazes, however, allow greater transparency with more pigment, and hence greater brilliance.

Washes can be produced in a variety of ways, as described on pages 27, 29–30. Any of these mixings can be used both for underpainting and for subsequent glazes.

The painting of a key colour as an underpainting, as described on page 50, is a good way to achieve unity and harmony in a glazed painting. If this particular technique is to be purely pursued, without recourse to opaque light colours, the first applications of wash should be chosen with care, and should not be too dark in tone. This is obvious when one considers that every succeeding layer of colour, however transparent, will cut down the amount of light reflected from the white ground, and therefore make the overpainted colour darker. Thus the light areas in the completed painting will be the untouched initial key layers, or the virgin white of the ground itself.

Glazing colour over a monochrome underpainting (page 53) is a specialized and rather difficult technique. It is difficult, that is, to attempt an absolutely complete underpainting in tones of grey which only requires colour glazes to complete it.

Fig 48

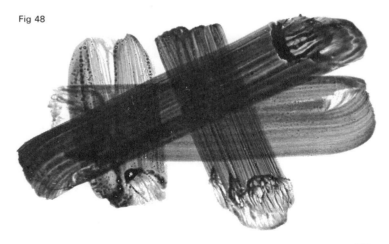

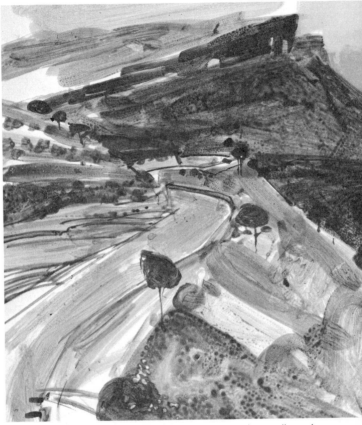

Fig 49 *View of Cassis, South France, from the mountains*, acrylic washes

However, if a slightly less 'pure' approach is accepted, it is not *so* difficult and can be very useful. The first necessity is to ensure clean, cool and not too dark greys in the underpainting. There must be sufficient medium in the underpainting to render it impervious to the later glazes. It can be opaque, and should be a little stronger in contrast than you wish the final result to appear. Pure glazes of colour, in several subtle layers or single brilliant ones, can then be overlayed. Each glaze will necessarily darken the tone, and in most cases lessen the contrast between dark and light. If detail is lost during glazing, through insufficiently-contrasty underpainting, it can always be reinforced by more grey and glazed again.

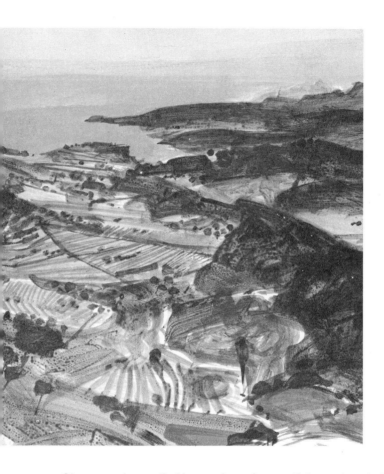

Glazes can be applied in a variety of ways. If the underpainting is dry, the glaze can be brushed on or wiped on with a cloth, or even poured on. If the underpainting is not dry enough for this, the glaze can be sprayed on. Always use pure colours without white admixture for glazes. Dilute the colour with matt or gloss acrylic medium and/or water, and control the tone by the amount of pigment. Never lighten tone with white. If a very transparent, lightly-coloured glaze is required, use gel medium, which can be mixed with the tiniest amount of pigment and still not become unmanageably runny.

Finally, always, always, ensure that water, brush and palette are scrupulously clean.

6 Scumbling

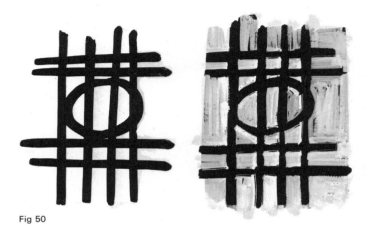

Fig 50

Fig 51 (opposite) Actual-size detail of illustration, showing scumbling

This term has been used somewhat imprecisely to describe a variety of methods of applying a more-or-less over-all opaque paint layer.

It has come to mean, for me, something a little different and more particular, and since there is no nearer word, short of inventing one, I will continue to use it in this book to refer to the technique I shall describe.

The effect is most obviously demonstrated in the painting of the girl's dress in the colour illustration on page 36. In this case, the underpainting (already described on page 51) was very dark, and the scumbling was effected by dragging on white paint, of a rather stiff consistency, using a flat, square-ended sable brush. The whole point of the operation is to allow underpainting to show through breaks in the scumbled layer but to be more-or-

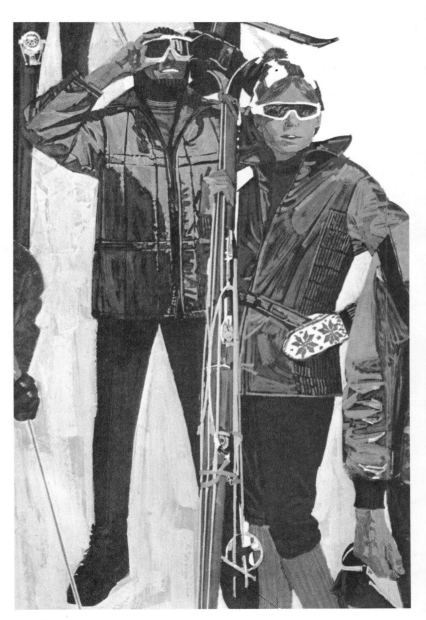

Fig 52 Detail from painting for ski-clothes brochure

less completely obliterated where it is covered. Therefore fairly opaque colours or white admixtures should be used, and generally the underpainting will be darker than the scumble. Several scumbled layers, becoming progressively lighter, can be used but not so many that the underpainting is completely covered. If this happens, the whole point of the dark underpainting will have been lost. The charm of a scumbled area depends on (1) richness of texture and (2) the very particular quality possessed by a dark area that has been formed as the 'shape left' between freely-applied light paint areas. As Fig. 50 shows, this is a very real distinction, although difficult to describe. It has a similar quality to that of a black line cut on a wood or lino block, which has resulted from a similar action, the raised printed part of the block having been left when the wood was cut away on each side.

The scumbled colour need not necessarily be in extreme contrast to the underpainting. If the colour used is strong in hue but quite close in tone to the underpainting, the combination of the fat broken colour and the darker thin underpainting, has the effect of enriching the total colour of the area, while giving a general tone darker than the scumbled colour alone. Colour used thus with restraint, and careful choice of hue, can enliven dead shadow areas.

If a dark line which should have been left to show through a scumbled area is accidentally painted over, or if an area meant to reveal a texture of the underpainting becomes solidly covered, either (1) wait for the scumble to dry, repaint the dark under-painting and try again; or (2) scrape off the scumbled layer with a palette knife while it is still wet, wipe clean with a sponge, and reapply. This method is only convenient when there are no sharp surrounding areas which would be spoiled by the wiping clean.

On page 60 is a part of a much larger illustration used to advertize ski clothes. It was important to show constructional details of the clothes and for the people to be sunlit and three dimensional, but not to lose freshness and spontaneity. The girl's anorak is an example of totally black underpainting, the colour (blue) of the anorak being dragged on to leave black detail lines and a texture in shadow areas. For the man's ski jacket only the shadow areas and stitching lines were under-painted, the light areas then painted up to and slightly into the dark, and a medium-tone colour of similar hue scumbled over the shadow.

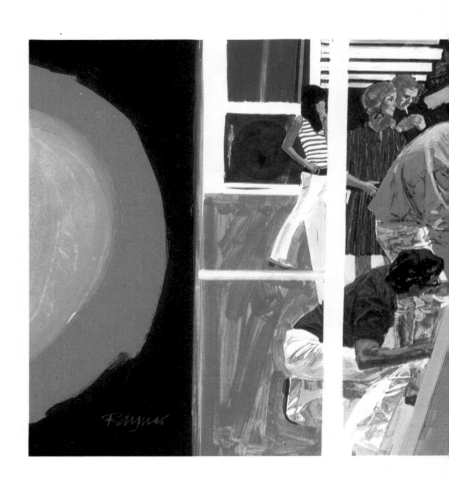

Fig 53 Illustration for press advertisement (*Martin Brinkmann AG, Bremen*)

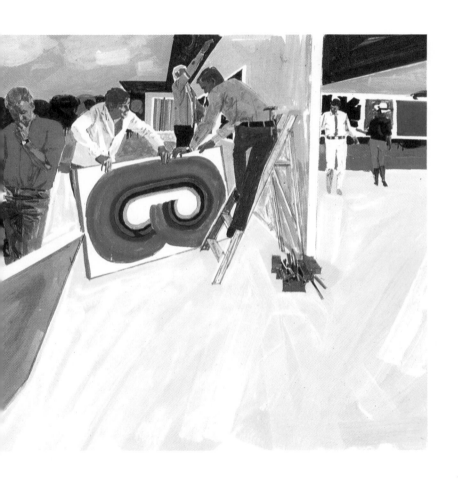

7 Painting outside

Painting with acrylics outdoors can be difficult, because the paints dry quickly on the palette (almost instantaneously it seems, under a hot sun).

There are three remedies:

1 Paint quickly and do not squeeze out too much colour at a time.

2 Spray retarder medium over the paint on the palette.

3 Occasionally spray a mist of water over palette colours.

The only trouble with using retarder medium is that it makes the paint dry rather more slowly on the painting too, and thus a big advantage of acrylics is lost.

Fig 54 *Hill at Kilve, North Somerset*

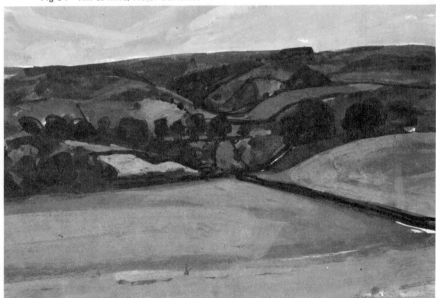

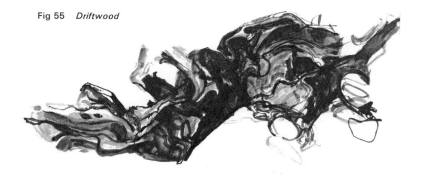

Fig 55 *Driftwood*

Always wash colour out of the brush as soon as you have finished using it – even five minutes in hot sun will make it difficult to clean. Any other difficulties are those attendant on any type of outdoor painting, and can be avoided by being properly equipped.

However much you may resist carrying easels, special paint boxes and the like, it is always much easier, when one is actually painting, to have everything that one needs. It is very important, for example, that water and acrylic medium are close by your hand and that they can't spill, and that whatever is being used for mixing paint on will not blow away. An overturned water pot in a place where no more water is available means packing up and returning with no drawing. So clip a container to the easel or paint box in some way. I use a fluid container and wire holder of the type that cyclists use clipped to their handlebars, which has been adapted slightly and secured to one leg of the easel. It is also preferable, if possible, to take a main bottle of water from which the smaller working container is replenished. This ensures cleaner water and protection against complete loss through accidental spilling.

Mixing on a piece of paper or cardboard, which is perfectly all right in the studio, is absolutely hopeless outdoors. It cannot be held with one hand, and it blows away all too easily if put down. Old-fashioned though it may seem, a palette, thumbhole and all, is the only satisfactory answer. White perspex (Plexiglass) is light

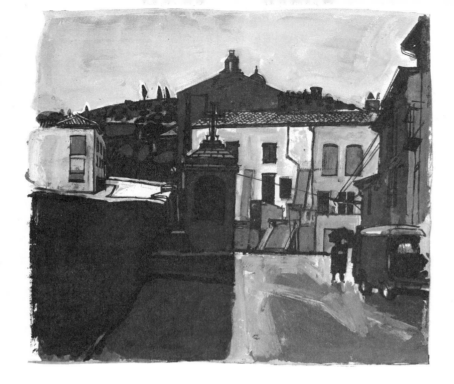

Fig 57 *La Ciotat, South France*

in weight, and can be roughly handled when cleaning, which is important when using acrylic paints, which dry very hard. A white palette also shows the colour as it will appear on the white ground of the painting.

Holding a palette with one hand and drawing or painting with the other, leaves one with the problem of supporting the painting surface in some way. It can be propped between the knees, which is not easy, or leaned against a tree or rock, which may not be available, so inevitably an easel becomes necessary.

An easel must be strong and rigid, or it is useless; and it must be light and compact or you won't bother to carry it. If well-designed and constructed, those made of alloy tube would seem to be the best for outdoor use. In very windy conditions it is almost impossible to hold a painting surface steady, and in

Fig 56 *Pine trees, South France* 67

my opinion a full painting (as opposed to a line-and-wash drawing) might as well not be attempted when it is very windy. In the South of France where many of the sketches in this book were done, there was, on occasions, a very strong and persistent wind, and it was quite impossible to support a board with an easel. Drawing on a hand-held board with paper firmly pinned to it was possible, but it was such a full-time job keeping everything intact, that using colour, medium, etc. was just too much to cope with.

Drawing from a car, in these conditions, is of course possible, but apart from the obvious difficulties of choice of spot, view is rather limited from most cars, and, more important, one cannot get back from the drawing at all. If the drawings are kept small, however, it *is* possible, and in really bad conditions when it would be impossible to work in the open, it is better than no drawing at all. The drawing on page 67 was produced from the car in the pouring rain. It was necessary to keep the windscreen wipers going the whole time in order to be able to see anything

Fig 58 *Loire Chateau, France*

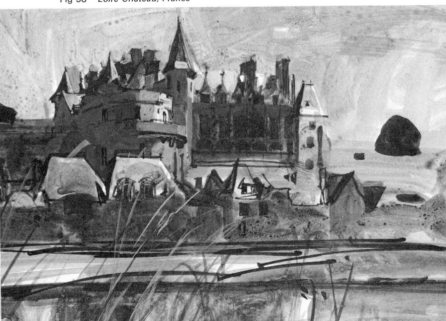

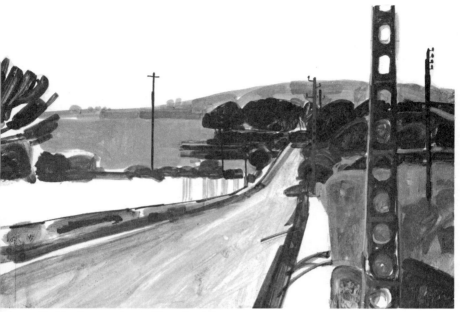

Fig 59 *Coast road to La Ciotat, South France*

at all! I suppose one day it will be normal to hover in a glass-bottomed helicopter and paint the formal patterns of land and townscape as seen from an aircraft. After all, the new perspectives that are shown to us via air travel, underwater swimming, the microscope and even telephoto lenses, are all genuine extensions of the observable world, and it is quite reasonable that we should, in this age, react to them in drawing and painting.

A paint box, useful anyway, is an essential for working outside. I have stressed the necessity of clean colour and of always mixing and using the colour that you *intend* rather than the colour that results from mixing whatever is left on the palette. I find that it only has to be a tiny bit difficult to find a particular tube of colour to persuade me almost subconsciously that the pigment already out will do. Most people, I think, have to combat this sort of laziness, and unless you are very strong-minded, the best answer is to make it very simple to reach for, find and return to its place the right tube of colour or brush or whatever.

Separating the paints into groups of colours, so that all the reds, say, are together, and the blues in another compartment and so on, has proved the most satisfactory arrangement for me. This is better than the usual ranging of tubes of colour in a more or less spectral order in one compartment, as it is almost impossible to keep them so orderly when painting, while it is quite simple to throw each tube back into one of six or eight compartments.

On page 23 is a drawing of my box for outdoor work. The outside box is a relatively cheap and simple attaché case, with flaps in the lid for documents etc. The divisions in the box were made from $\frac{1}{8}$ in.-thick plywood slotted together as Fig. 14, and glued or tacked where necessary. The arrangement of the compartments was dictated by my own particular needs and sizes of brushes, tubes, water pot, etc., and of course many other layouts are possible. If you decide to adopt a similar system, I suggest that you should first draw a plan of the box you intend to use and

Fig 60 *Buncombe Hill, North Somerset*

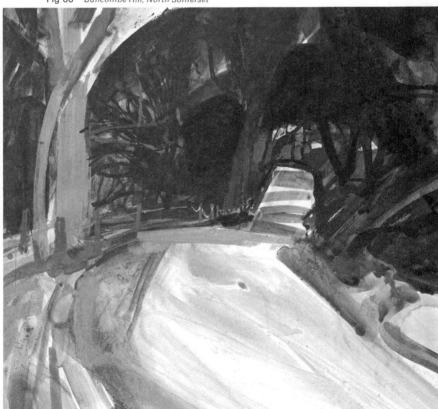

Fig 61 *Boats at La Ciotat, South France,* stage 1

divide it into square inches or whatever units are convenient. Give some thought to it and then draw in, to the same scale, the things that you need to take, and so plan the most efficient use of the space. If the layout can be a little flexible, all the better – for example, the division between compartments 5 and 6 (Fig. 15) is removable, so that larger tubes of colour can be carried if needed. The space allocated to water pot may seem rather lavish, but I think it is about the minimum, when you consider that the one pot has to carry water both for washing brushes and for helping to dilute colour. In fact, as previously mentioned, a separate container of water clipped to the easel, or even yet another larger bottle of water, would be advisable if you are likely to be away painting for a whole day. The lid of the painting box can be utilized for carrying palette, rags, note-book, sketch book etc. – the document flaps in my box were useful for this, and the palette was cut from perspex (Plexiglass) to fit. I also carry a mirror for viewing drawings in reverse and therefore freshly, as discussed on page 86.

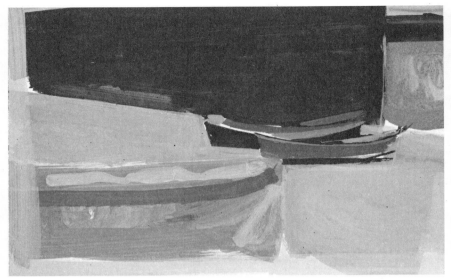

Fig 62 *Boats at La Ciotat, South France*, stage 2

So now the list of equipment reads:

1 EASEL
Light folding easel, plus attached plastic water pot if possible

2 PAINTING BOX
paints
brushes, pens, pencils, palette knife
medium (matt, gloss and gel)
palette
water
rag
some drawing pins (thumb tacks)
spare pen nibs, sticky (adhesive) tape
pencil sharpener or knife

All that remains is:

3 PAINTING SURFACES
Since acrylics dry quickly, canvas pins to hold face to face and
protect wet surfaces, as with oil painting, are not necessary.

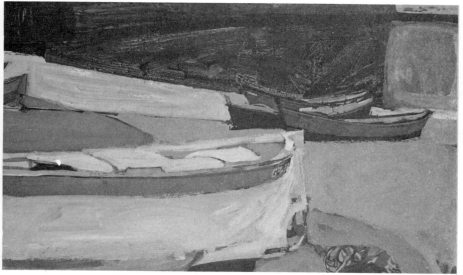

Fig 63 *Boats at La Ciotat, South France,* stage 3

So any convenient size and thickness of painting surface can be taken and packed together after painting, with no fear of damage. Exactly what surface is painted on is very much a personal choice. It can be stretched canvas, board, paper, wood or metal panels – almost anything, and they can be prepared in a variety of ways (see materials chapter, page 21). The main factors governing your choice for outdoor work will be ease of carrying, rigidity, likely subjects and time available for painting. In general, work as large as practicable, unless you have a particular leaning towards miniature drawings. Drawing and painting very small is not usually advisable, but the paintings of Samuel Palmer (1805–81), for instance, show that small size does not necessarily mean insignificance.

If paper is your choice to work on, use tape, pins (thumb tacks) or clips to fasten it *firmly* to a board – one drawing pin (thumb tack) or even two, just will not do. I generally use a sort of thin cardboard which is coated with a thin layer of China Clay and is very smooth and shiny. It is commonly used in the printing trade and is known by a variety of trade names, but 'coated card' ('coated cover stock' or 'coated tag stock' in the U.S.) would identify it or something similar. This card doesn't cockle (buckle) too much when very wet paint is applied, but thinner paper will of course,

Fig 64 *Coastal view, South France*

and would have to be mounted or stretched as described on page 22. I am personally not very much in favour of stretching paper for outdoor use. Firstly because it is rather a bother to do, and tends to make one rather over-careful when working, so as not to spoil and waste it, and secondly because one board can only accommodate one piece of paper, two at the most if both sides of the board are used, which is not really advisable. Of course not too many stretched canvases can be carried, but if canvas is being used, one feels that rather more than a quick study is intended, so probably two will be enough. Never have only one painting surface – you will surely make a mess of it by being too nervous and tentative. A portfolio or waterproof envelope is a good idea too. You may think protection against storm and tempest has been overstressed, but believe me, it can blow and rain in the most unlikely places, even the South of France in June! Finally, if one is going to have to walk far, a carrying frame, Yukon style, is the best for carrying everything, although a rucksack with extra straps is good too.

Perhaps this will seem rather a long list of equipment, but if properly planned it only amounts to a portfolio, and a compact case containing everything, with perhaps the folding easel strapped to it.

74

As to actually painting outdoors, in most respects it is very much the same as anywhere else. Don't take too long deciding what to paint, one can go on all day looking for somewhere just a little better. On the other hand, when you have decided on a spot, don't be in too much of a hurry to begin. Look at the place, consider its general character, decide what its general colour is, and try to discover what, above all, you feel about it. What made you stop there? Consider its abstract qualities, look for the big shapes, and, most important in landscape, the changes in level. The main interest for me when doing the painting shown in two stages on pages 78 and 76–77, was a matter of levels. The road on the left was one positive flat plane, not running horizontally – as can be seen by reference to the horizon at the right – but in strong contrast to the tunnel-like descent through trees to sea level; and the steep, straight ascent to the top of the promontory at the right leading to the establishment of the horizon.

Fig 65 *Barren landscape, near La Ciotat, South France*

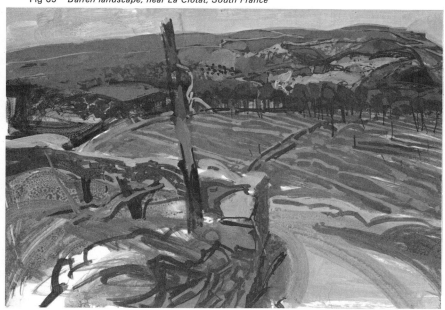

Fig 66 *Path to beach at Les Lecques, South France*

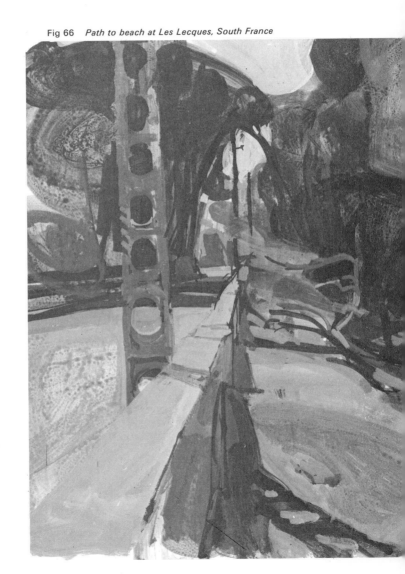

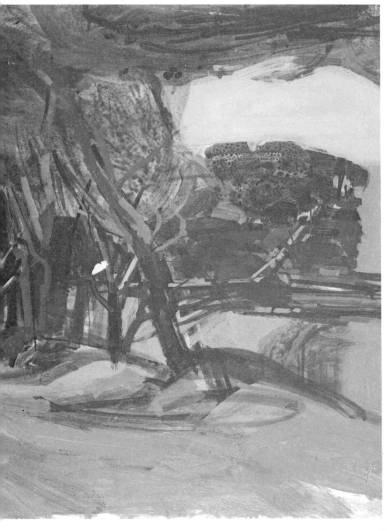

Fig 68 *Beach at Kilve, North Somerset*

Only these aspects interested me, and I tried only to delineate as much of the landscape as was required to describe these three levels, almost like three landscapes in one. Even the pre-cast telephone pole, which you may think a bit unnecessary, is there to establish scale and recession along the road. That was the intention, maybe it wasn't successful, but you must have some such single purpose. Otherwise, anything and everything has to go in, it is just not possible to know when to stop, and it will end up as a muddle.

Stage 1 in Fig. 67 is really stage 2, I suppose, the main compositional lines having been established and then amplified into a broad suggestion of the planes I have mentioned. I was in a hurry to get this down before the sun moved round too much, and it wasn't until this point that I felt I could pause long enough to make a photographic copy of the painting. For this is not a made-up progression drawing, this is actually a photograph of the painting on pages 76–77 at an earlier stage. I have to confess that the three stages on pages 71, 72 and 73 are in fact three separate drawings, but they do show a typical progression from the first establishment of abstract composition to a fairly objective three-dimensional end. The degree of 'realism', in the objective sense, that you attempt to achieve, is a personal choice, but I think one should never go so far as to submerge completely the abstract pattern which is discovered in the early stages.

Fig 67 Stage 1 of Fig. 66

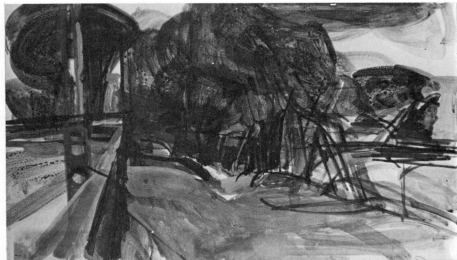

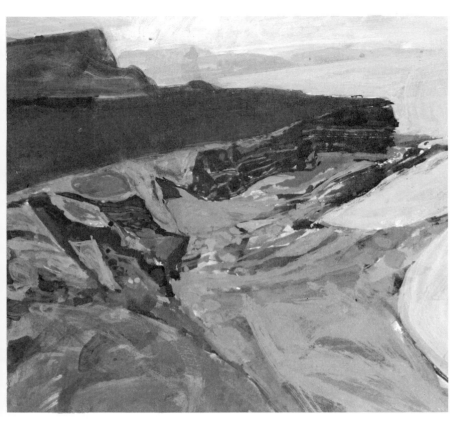

I referred earlier to the compositional value of a telephone pole, and you may have noticed such outdoor furniture appearing in other sketches. There has been a tendency among some landscape painters, not necessarily amateurs, to paint landscape as though the railway, the motor-car and electricity had never arrived. Telephone poles, electricity pylons, railways, roads and traffic signs are with us, they are *part* of the landscape – most landscape anyway – and they are very characteristic of some countryside. Anyway, I think many of the man-made additions are rather beautiful. There's something quite fascinating about the way a road punctuates a landscape – its dips and curves, or its flat straightness, show us· what is happening to the surfaces it lies on, and I think it gives a centre where sometimes there is none. By the same token, don't necessarily draw only old, quaint buildings – true, many of the most beautiful *are* old, but a building's modernity should not put it beyond the pale. Draw and paint the world, as you see it. It implies choice of course, but be careful that it's your choice.

Fig 69 *Seated nude*

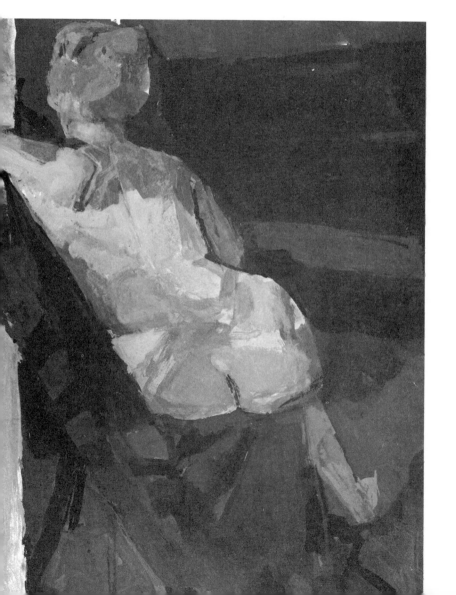

8 Studio painting

Fig 70

Painting indoors generally presents fewer practical problems than working outside. One can spread oneself, use heavier equipment, take more time. Two things, however, may be in short supply. One is light and the other is space. Obviously, both depend on the room available as a studio, and really the lightest and largest room that can be continuously used as a workroom is the best. Continually having to clear away to allow the room to revert to a dining-room or the like is really not very good. If a large, well-lit room is available, then there are no problems, but if it is only a relatively small and not so well-lit room, one must try to make the most of what space and light there is. Move out or away all the furniture which is not necessary, so as to clear as much floor space as possible and to allow plenty of reflective wall surface. Paint the walls pure white, especially the one opposite the window. Make sure the window is clean and draw the curtains right back, away from the window edge if possible. It is surprising how much difference fairly simple measures such as these can make.

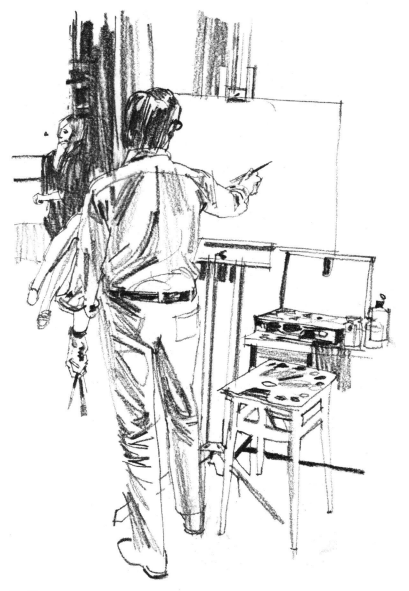

Fig 71

Fig 72 *Reclining nude*

The next essential in my opinion is order. Even if the studio is vast, with plenty of room for clutter, I consider that the immediate vicinity of the painting should be properly organized. Place the easel so that plenty of light will fall on the painting surface in such a way as not to be shadowed by the painting arm or anything else, i.e. light from above and behind your left shoulder if right-handed, and from the right side if left-handed. The palette, if not held, should be on a table or stool at a convenient height and at least as well lit as the canvas. Before beginning to paint, make sure that the easel is upright and the canvas straight on it. Line up the edges with a vertical line of a door or window. A leaning canvas is surprisingly disruptive of structure and balance in a composition. If the intention is to paint from a model, whether live or inanimate, make sure that he, she or it is visible with a minimum of head movement, and not viewed over the painting arm.

Still life is usually the first studio subject, but I do not propose to deal with it as a special subject. It has been written about a good deal in other places (there is a book about it in the same series as this book), and instead I want to talk about painting people. Almost everything I shall say about composing a figure com-position or painting a portrait will apply equally well to a still-life painting anyway.

Fig. 69 is a black and white reproduction of a full-colour acrylic painting. It is only a two or three-hour sketch, but may suggest how a figure can be used as an element in a complete environment.

Fig 73 *Reclining nude*

What one cannot see in this monochrome version is that the drape on the model's chair was bright orange-yellow and the only piece of strong colour there. The large shape to the left of her was all pale greys and blues, and the sculptured shapes on top were darker versions of the same. Even the figure, although warmer in the lights, had pearly blues and greens and cold mauves in the shadow areas. The abstract pattern of these shapes of colour and tone was very strong and compulsive, and the interplay of these forms one with the other was what I was interested in and tried to put down.

I mention all this, not because I think the result is so marvellous, but because for an objective painting the approach is a good one. One should not try to describe every aspect of everything that you see. Limit the vocabulary and say one thing *strongly*. When looking at a painting, one needs to know not just what the object looked like-the camera could tell us that-but what was specially interesting about it.

Again, don't necessarily view the model from one place only. There are likely to be many different patterns and compositions to discover, and an accumulation of visual information from all round an object helps the eventual single view to be more incisive. Also, although it may not be a strictly-objective approach, there is really no reason why several sides of an object shouldn't be combined into one. Picasso does it, so why not you?

It is helpful, when drawing from life, to try to see the figure as it is at that moment, in that situation, as though you had never seen a human figure before and know nothing of what it should, or could, be like. To explain this further, I ask you to consider your arm, say, folded so that the forearm rests across your waist, maybe the hand cupping the elbow. Now, everybody knows that it is an arm and that in a moment it can be stretched out and away from the body, but while it is resting against the body it is as one form with it. In *that* situation, at *that* moment, it is continuous with the planes of the body that it touches. If you think about all the forms you can see in this way, strong generalities of plane and structure will be revealed, which would otherwise be obscured by superficial detail and foreknowledge.

Another device that helps to freshen one's vision is to look at the model and/or your painting via its reflection in a mirror. One can become surprisingly blind to quite obvious faults in a drawing or painting, and to the important large shape of an object. In both cases this is the result of increasing observation of detail, which is the natural progression from first-time general vision.

Fig 74 Illustration for magazine story

Unfortunately, this detail concentration tends to exclude or distort over-all vision, but reversing the view in a mirror makes one see it new and fresh again, as though for the first time.

Some of the acrylic paintings reproduced in this book are illustrations commissioned for reproduction in magazines and books, for which purpose acrylics are well suited. Fast drying times, allowing quick overpainting, and the elasticity and resistance to damage of the surface are very desirable qualities for illustration work. Also, those particularly brilliant but fugitive organic lake pigments can be used because, unlike permanent paintings, it is only necessary that the colours remain true long enough to be photographed by the process cameras. After that it doesn't matter if they fade, the original colours can be reproduced by the printer's inks for evermore, if desired.

Figs 75, 76 and 77 show stages of a painting which was actually used to illustrate a magazine story, but it could equally well be a portrait or a still life. The method is a generally good one, indeed almost standard practice, and it has the advantage of allowing the painting to progress as a whole. Small details evolve in their proper places, rather than being completed too early, in the wrong place, or dissociated. Before discussing the steps in detail, I want to stress that this is not by any means the only way to tackle a painting successfully. Some painters like to organize and draw up the whole thing first, and then start from one corner and work across the painting, colouring in the shapes. Others search for shapes that will make up the composition in a very delicate and fragmentary way, mapping the painting surface with tiny explorative ticks and spots, the forms emerging gradually from an apparently meaningless cypher. There is no one way, but the order of events I shall describe has some advantages for a beginner.

The underpainting used here could be described as a combination of single key colour, dark for paint-back and thin to fat (see Underpainting, page 50). The general colour key of the painting was blue-purple, and Fig. 75 shows the large areas of free, bubbly wash that were first applied. The whole purpose of this first stage is the establishment of the main compositional shape (in this case cruciform) and at the same time the laying down of bold, clear colours which will to some extent pervade the whole painting, and may in part be left untouched in the finished painting. Boldness and vivacity are essential at this stage, as subsequent painting will tend gradually to tame everything down.

In the next-stage illustration, the secondary areas of pattern and

Fig 75 Illustration for magazine story, two old ladies, stage 1

colour have been put down. The figures of the two old ladies, who are the subject of the illustration, emerged as part of the same process. It is the relationship of one figure to the other, rather than the particulars of each figure, which should concern one at this stage.

Once started on the overpainting, there was no clear-cut staging of the illustration, but between stage 2 and the final illustration shown on page 91, more explicit shapes were

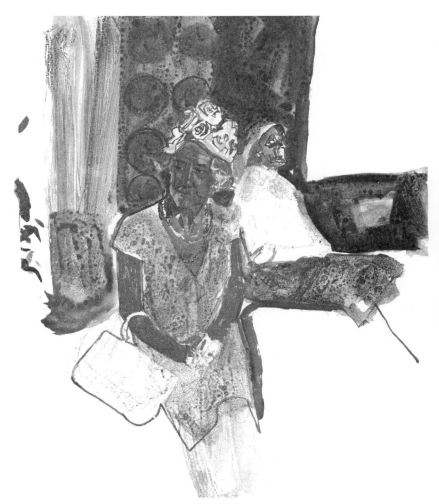

Fig 76 Illustration for magazine story, two old ladies, stage 2

gradually introduced, trying all the while to retain a coherent whole.

Some texture (modelling) paste was applied with a palette-knife to create some interest in the top right-hand corner of white, and some thicker paint introduced into the flesh areas. The flowered hats were painted quite thickly with white paint, for subsequent glazing with transparent blue. Shadow areas, divisions between fingers, etc., were drawn in blues and greens, and warm opaque oranges and yellows used for the light on arms

90

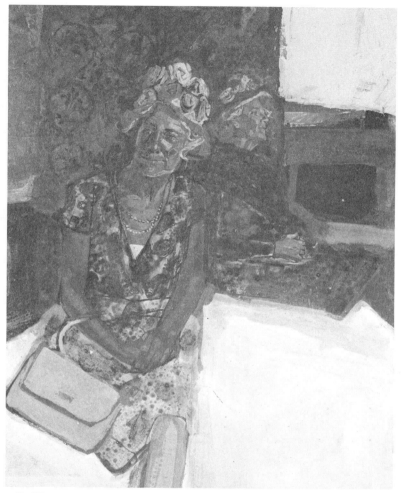

Fig 77 Illustration for magazine story, two old ladies, stage 3

and faces. At no time was any opaque colour applied on the dresses or the background. Very many closely-related purples, mauves, greens and pinks were used in linear patterns or general glazes, but no white was admixed. White paint, applied freely with a large brush, was used to re-establish the large white spaces. Lines in pale blue and dark purple were drawn around some of the shapes of colour to re-emphasize their abstract pattern, when they seemed to become lost in the realism necessary for the character detail of the two ladies. Recognition details

mentioned in the story, such as wisps of hair escaping from their blue flowered hats, were the last to be delineated.

The decision that a painting is complete can be a difficult one to make. It is not necessarily finished when all the details are there, or necessarily unfinished when they are not; but has more to do with its rightness for the purpose. When the point or statement you wished to make is complete, i.e. when the particular aspect of your visual discovery is as right and as strong as you can make it, and in a form which will mean something to whoever is to look at it, then it is finished. There is always the danger that one will go too far and the original strong statement will become lost or diminished by irrelevant over-elaboration, or just plain over-working. If this appears to be happening, it's no good fiddling with minor changes. Take courage and restate the strong shapes which have been lost. Take a big brush and ruthlessly hack some life into the painting. If a few treasured little bits of detail are spoiled in the process, so be it, the whole painting is more important than any single part of it. Such rejuvenating measures may take the form of violent strokes of colour, which become part of the finished picture in themselves. Alternatively, whole areas can be scraped down, painted white and repainted freshly again. There is no need for dismay that such changes become necessary; paintings do not often proceed by measured, pre-ordained steps to a planned conclusion, and nor should they. Change and modification are essential parts of the normal process of painting.

Although there is no necessity with acrylics to stop and wait for paint to dry, as with oil paints, it is good to put a studio painting aside for a while if it seems to be dragging on and not getting anywhere. Go for a walk or a cup of coffee, or even start another painting altogether. What was wrong, and how one should continue, is often transparently obvious when one returns to the painting, and one can attack it again with energy.

A final practical point: whenever you pause, whatever the reason, take the opportunity to empty and refill water pots, and clean the mixing area of the palette if nearly covered. Never leave brushes out with paint or medium in them. It is better to leave them in the water pot, but better still to rinse them out in water and wipe them. At the end of painting for the day all brushes, but sables especially, should be carefully washed in warm, soapy water and the hairs eased back into shape. Check that all the paint tubes have their caps on properly and are put away in their appropriate compartments. It is a good thing psychologically to come back to a painting and be able to re-start clean straightaway.

9 Collage

Fig 78

An unexpected bonus in the use of acrylic medium is its remarkable efficiency as an adhesive. Almost anything can be stuck permanently to the surface of a painting simply by incorporating it in a coating film of acrylic medium. Pictures made up of bits and pieces of all sorts of material other than paint are known as collage paintings, or just collages.

Collage paintings are usually non-figurative in entirety, although they may contain fragments of realism in the form of photographs or pieces of reproduced pictures, posters etc. For objective painting, collage has limited use, I feel. It is possible to achieve extraordinarily convincing renderings of realistic light and shade, colour and form, using pieces of coloured paper only, and it is an interesting exercise. But the same thing can be achieved so much more easily with paint that to use paper collage regularly instead of paints would seem to be merely demonstrating skill and ingenuity for its own sake. Please note that these remarks do *not* apply to the occasional use of coloured paper, sand, etc. in addition to paint, in places where it enriches and assists by combination with it. Such mixed-media objective painting is fine, and, with acrylic medium, free from technical complications.

When used for non-figurative or abstract painting then (and it is not always easy to draw a definite line between figurative and abstract, see chapter on pattern-making in my book in this series *Starting to paint in oils*), collage can be divided into at least three classes. Firstly, totally abstract and formal, where the decorative pattern of colour and form is the whole point. Secondly, abstract in form but containing readable, written messages and objects or pictures which suggest more or less obviously a

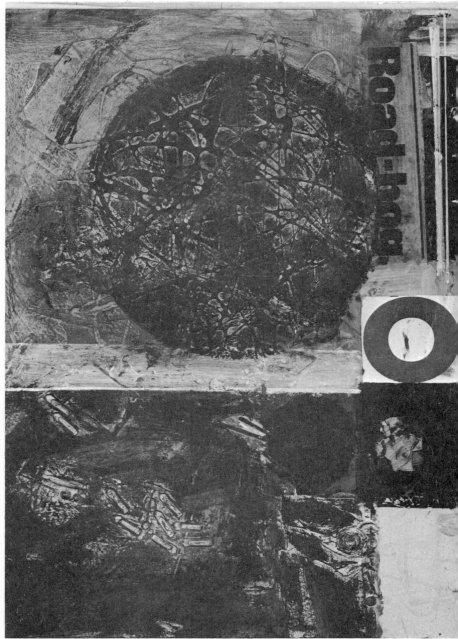

Fig 79 Collage of three-dimensional bits and pieces, newspaper cuttings etc.

Fig 80 High relief collage

theme or point. Thirdly, collections of objects which shock or surprise by their incongruity or mutual disparity. Whatever one's intention, it is necessary to organize the basic shapes carefully, and see the painting as a whole, exactly as one does with any painting. The problems of composition are the same, and one must be careful not to distribute a lot of tiny-detailed, unrelated forms evenly across the surface of the painting. There is a temptation, which must be resisted, to use all the lovely little fragments that are available, regardless of the needs of the particular composition as a whole. Group the areas of complexity so that they counter-balance big flat forms, and try not to introduce too many ideas into one painting.

There are so many, many different things and types of material that can be utilized in a collage that it would be pointless to try to list them. If one is interested in making collages, any interesting bits and pieces should be saved, collected together and continuously added to, so that one has plenty of choice of colour, form and texture when a picture is to be constructed.

Paper of all types, including coloured tissues, silver and gold foil, newspaper and magazine cuttings, tickets etc., and all such basically flat material, needs only to be pressed onto a freshly-applied film of acrylic medium and coated with a further layer. When dry the applied pieces will be permanently sealed in position.

Objects such as match sticks, pins, paper clips, fuses, pieces of string and wool (yarn), twigs, milk bottle tops, lids of all types, pieces of ceramic tile, plastic, glass etc., are rather easier to affix

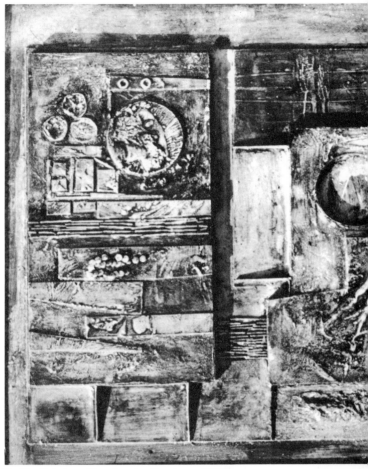

Fig 81 Painting with collage by Alan Jessett MSIA

if pressed into a thicker layer of gel medium.

Such high-relief objects as boxes, clock parts, pieces of radio and electronic circuitry, shells, pebbles, and so on, can be initially embedded in texture (modelling) paste and subsequently sealed in with gel medium.

When an interesting surface has been built up, it can be partly or wholly painted over with acrylic white, and glazed with transparent colours. Interesting textures can then be achieved by rubbing the surface with a rag and methylated spirits (de-

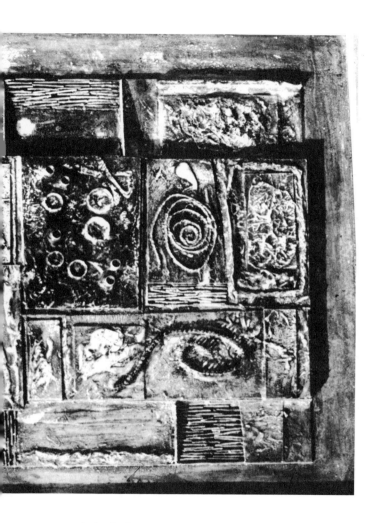

natured alcohol), or acetone, which softens the acrylic colour film and removes it from the upper surfaces, while leaving the depressions untouched, so dramatizing the form. Try pouring and spraying, scraping, multiple glazing and anything else you can think of. Experiment freely and discover the outer limits of what acrylic paints will do.

On returning to more traditional objective painting, the broadening effect will be evident in increased confidence in paint handling and more inventive compositions.

Fig 82 Monoprints

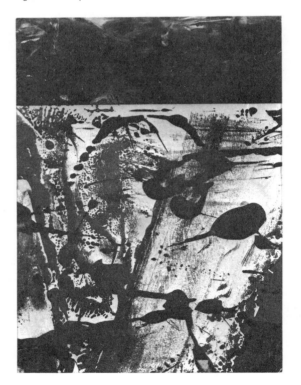

10 Varnishing, mounting (matting) and framing

Fig 83

Acrylic painting need not necessarily be varnished, but varnish does provide an extra protective layer, and it also enhances the brilliance and depth of colour in many cases. Some colours may contain less medium, especially if gouache paint with added acrylic medium has been used, and may have gone a little flat in colour. A coat of varnish will immediately bring this up to an enhanced brilliance, albeit with a slight lowering of the tone value. Glazes too seem to gain in depth and lustre by receiving the extra layer of clear varnish, but opaque lights are virtually unaffected.

Water-based matt and gloss acrylic varnishes are provided by some manufacturers. These, although similar to the matt and gloss mediums, are designed specially for varnishing, and should be used for it. Other manufacturers do not make a special varnish, and in these cases matt and gloss mediums can themselves be used as a final coating and may be mixed with water, or mixed together with water, so as to achieve any desired degree of final gloss. Care must be taken in this case that all the paint has dried hard and that areas of opaque colour are sufficiently rich in acrylic medium to be impervious to smudging. If all the colours used were pre-mixed acrylics, there is no need to worry, but if only a little white gouache, for example, has been used without any medium, it will be spread all over the painting by the brushing action. If any paint areas are suspect, coat them first by spraying with medium, or use a spirit varnish instead. An acrylic spirit varnish (not water-soluble, but petroleum-based) will not disturb any unfixed pure gouache or watercolour, and it has the additional advantage of being easily removable if necessary. Naphtha or turpentine will remove this type of varnish without disturbing the acrylic paint beneath, and may also be used for thinning the varnish. Always

apply varnish with a large flat brush, stroking the surface evenly and smoothly so as not to produce bubbling, applying several thin layers, rather than one thick one. Spirit varnish dries rather more slowly than acrylic medium, and must be protected from dust, hairs etc. until it is hard. Be very wary of spray-on pastel fixatives, some of these preparations are quite effective as a varnish or for pre-varnish fixing, but others soften and lift the acrylic paint film. It is best therefore to avoid them, and stick to the varnish recommended by the acrylic paint manufacturer.

When preparing acrylic paintings for display, one has the choice of framing, as an oil painting normally is, or mounting and framing as a watercolour. The decision will probably depend on the size of the painting and the robustness of the technique employed. Paintings larger than say 18 in. × 24 in. will probably look best with a frame only. Narrow frames, perhaps only an edging strip, are preferred nowadays and can easily be constructed.

For a simple edging strip it is only necessary to cut four battens (thin wood strips) to the correct length with 45° mitred ends – using a mitre block (miter box) – and pin (tack) them to the edges of the canvas. If the painting is on board, battens (thin wood strips) must first be affixed to the back edges to provide some thickness into which to nail. Simple frames can be made by cutting mitre ends to lengths of building or picture mouldings and gluing and pinning (tacking) the corners together. At least one corner cramp (clamp), but preferably two or four, is necessary, in order to hold each corner firmly in the right position for tacking. The mitres should be coated with a strong glue, brought together and held in the corner cramp, and then nailed with panel pins (carpenter's tacks) driven from each outer edge near the corner, through one mitre into the other. Several simple building mouldings or even regular timbers can be combined to make wider and more impressive frames, which can then be primed with acrylic primer (acrylic gesso) and glazed with transparent, subtle colour. Keep colours simple though; the function of a frame is the focusing of attention on the picture, not on itself.

Much of the work in one's portfolio, however, is likely to be sketches, line and wash drawings and paintings on paper or cardboard. These will almost certainly benefit from being mounted (matted), even if not intended to be framed and hung on the wall. Special mounting (mat) boards, which are more softly constituted than other cardboard, are available in a variety of colours at most art shops.

Fig 84

Cut two L-shaped pieces of cardboard to represent the final mount (mat), and move them until the best position is decided upon. Measure the window, averaging out any discrepancy due to un-square positioning of 'L' masks (Fig. 84).

Fig 85

Work from one long edge and on the *back* of the board. Measure the desired width of one margin and mark in two places. Draw a line parallel to this edge. Do not trust the board to be square; only measure in from one edge (Fig. 85).

Fig 86

Using a set square (triangle) establish a second line at 90° to the first. Measure and mark the shorter dimension of the window along this edge, and also from the other end of the long line. Repeat for the longer dimension. Draw the two other sides through the four marks (Fig. 86).

Fig 87

For cutting, lay board on spare strawboard, cardboard, or similar smooth, not too hard, surface. Using a steel straight-edge and sharp blade, cut along the lines marked, overcutting at the corners just sufficiently to allow the corners to come out cleanly on the other (front) side (Fig. 87).

Fig 88

A method of preparing and cutting masks or mounts (mats) has been explained and illustrated on the previous page. In picture 4 (Fig. 87) the straight-edge actually being used is bevelled. If a bevel mount (mat) is to be attempted, and it takes some practice, a mount (mat)-cutting knife, which has a stronger blade than the usual trim knife, must be used. The straight-edge must be placed *inside* the edge to be cut, the blade pressed flat against the bevel and the cut made by moving the whole arm, keeping the fingers, hand and blade absolutely fixed. If the blade is really sharp it may be possible to get through the board in one go, but if not, replace the blade against the bevel at exactly the same angle and repeat the movement as necessary.

A very useful device for quick and easy display of a drawing or painting, either mounted (matted) or unmounted (not matted), is illustrated on this page. It consists of a standard mounting (mat) board, backed by a piece of plywood the same size, covered with a sheet of clear perspex (Plexiglass) or glass. All three are held together by clips, which can be easily removed, and the whole mount can be hung on the wall from eye screws on the back. Any drawing that one feels like living with for a while is sandwiched between the mounting (mat) board and the perspex (Plexiglass), the whole clipped together and hung in a matter of minutes. I personally prefer this method to permanent framing.

11 Conclusion

Fig 89 *Christmas Presents* by Polly Raynes, aged 5 years 10 months

The automobile, blamed for a great deal, can at least claim some credit for motivating the research which has led to these most beautiful and durable new acrylic paints. Acrylic polymer resins have freed painters from the need for constant consideration of the chemical 'do's and dont's' of painting. Almost anything is allowed with these forgiving new materials, and there seem to be no serious disadvantages. The range of colours now available, with the introduction of new organic pigments, is wider than ever before, and approaching more nearly the purity and saturation of the spectral hues. No doubt there are more acrylic mediums and newer, brighter organic pigments yet to be developed. And all this is in addition to the marvellous ranges of pastels, chalks, wax crayons, watercolours, gouache, oil paints, fluorescents etc. already available.

But not only painters benefit. Brighter, faster dyestuffs and pigments mean more brilliant fabrics, wallpapers, house paints, toys, plastics, furniture, films than ever before. The whole world is more colourful, and consequently our visual experience is too. What one sees forms the basis of what one expresses. We need these colours, to express ourselves about the world that contains them

Index